The Word On The Street

Street messages from around the world

Peter V.G. Kristiansen

Amazon Edition
1st B&W Edition
© 2014 by Peter V.G. Kristiansen
All rights reserved.
ISBN: 978-1503253353
Published by CreateSpace LLC
All photos copyright by and displayed courtesy of the author and "The TWOTS Project".

THE WORD ON THE STREET

List of Content

Introduction

Street Messages

Feedback

About the author

Other titles by the author

Introduction

Since the beginning of the history of mankind, human beings have written or painted their living environment or thoughts on walls. Whether it had been ancient cave-paintings, where mostly animals have been depicted or the giant reliefs by the Mayans or Egyptians, where whole stories are being told. Political campaigns have written their slogans on walls throughout the whole history and called for resistance or criticised deficits in society.

Today huge billboards with advertising and empty messages are dominating the image of our streets, but there are many artists who leave their personal, philosophical, lyrical or political texts. Whole cities decorate their facades with poems and political organisations use the methods of graffiti and the advertising industry to spread their messages to a wider audience.

"The Word On The Street" displays some of the best street messages I have come across done by artists from around the world, who work with texts in the streets. By nature, artists from countries with a long graffiti tradition are highlighted, but the light also goes to countries that have been partly neglected during the graffiti boom. Countries like the UAE, Syria or Yemen where graffiti and written messages play an important role in the resistance against the suppressive regimes in those countries.
Especially one street message artist from Dubai known by his tag name "Arcadia Blank" is frequently featured in this book and my sincere thanks goes to him and his colleagues who have proved over and over that even in a conservative, Muslim society like the UAE governed largely by Sharia law it is possible to get the word out in

the streets and brighten up people's day - even if it comes at a potentially high personal risk and ultimately very dire consequences if caught.

Although some of the artists whose messages are depicted in this book are careful as to where they display their art, ultimately it is seen as an illegal act in many countries. Arcadia Blank, to name one, mostly uses temporary structures such as fences around construction sites to avoid being accused of vandalism.

Sadly, however, others are less careful in their choice of 'canvas'. In August 2014, two men were sentenced to each spend three years in prison in Malaysia for writing their messages on walls of Kuala Lumpur, so it can be a dangerous art form if the artist is not very careful.

Ultimately, street messengers are exercising what they see as a freedom of speech; an artistic freedom they see a something fundamental in society, whether the freedom is recognised by the authorities or not.

Street messages are everywhere. They have become part of life no matter where you go on the planet. They are there with their messages to make us reflect, to move us and to make us think about our lives and living conditions.

I hope you will enjoy the samples displayed in this book.

Street messages from around the world

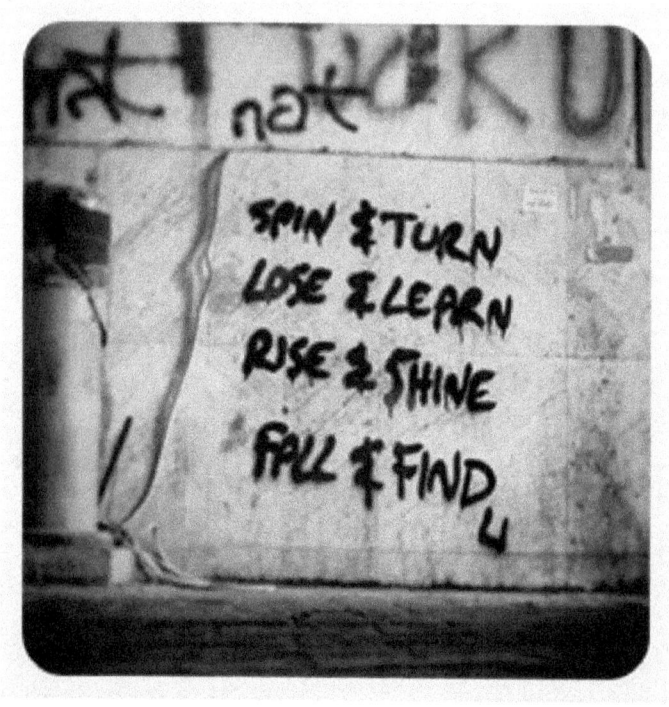

Spin & Turn
Lose & Learn
Rise & Shine
Fall & Find.

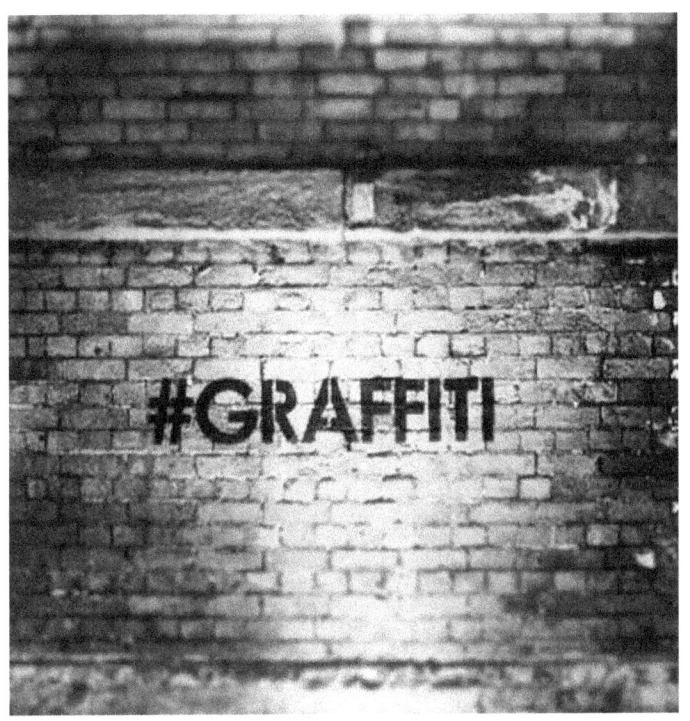

#Graffiti.

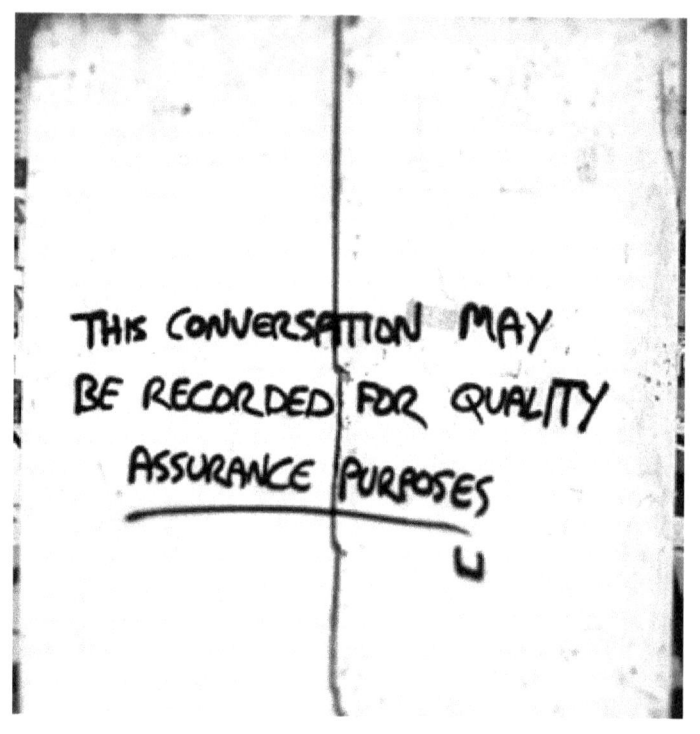

This conversation may be recorded for quality assurance purposes.

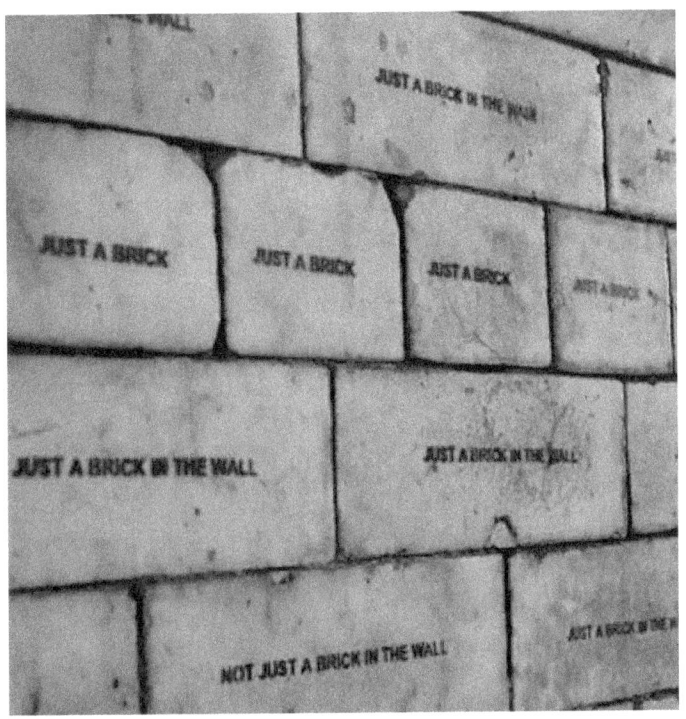

Not just a brick in the wall.

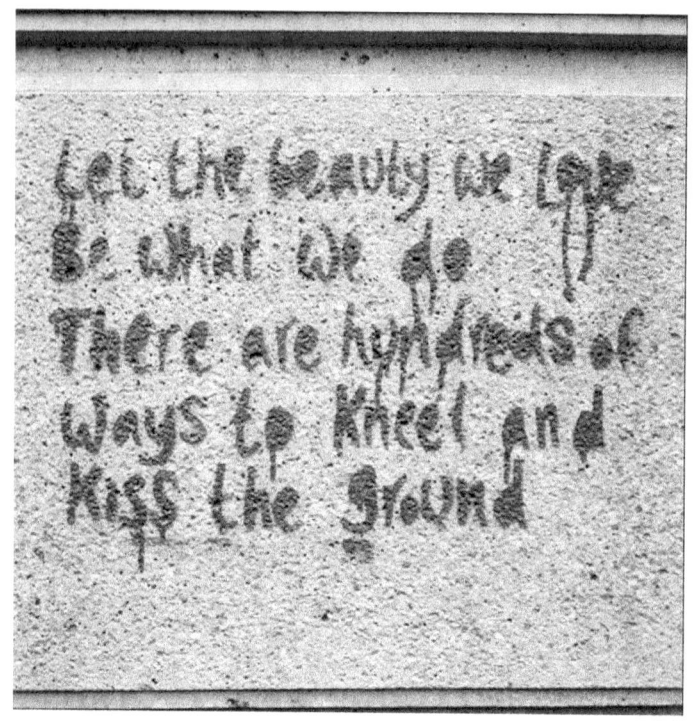

Let the beauty we love be what we do.
There are hundreds of ways to kneel and kiss the ground.
- Rumi.

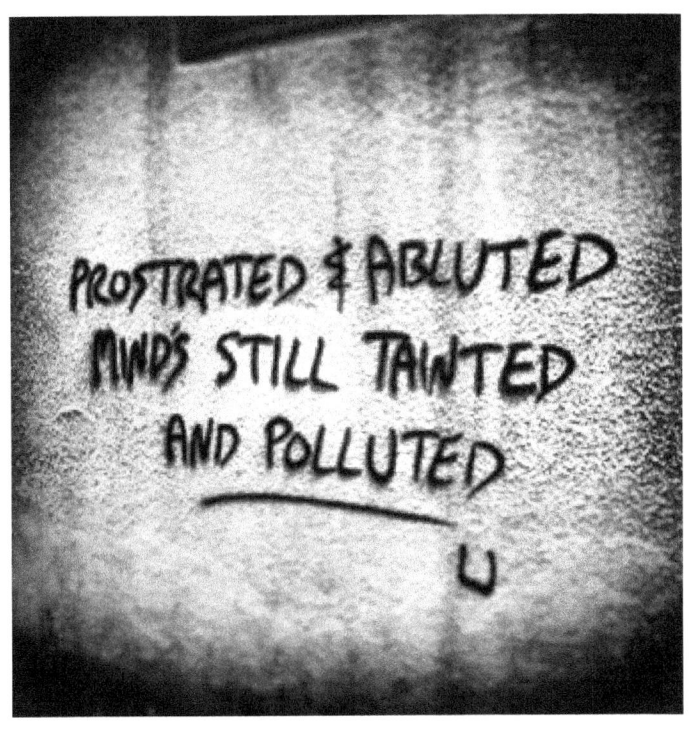

Prostrated & abluted, mind's still tawted and polluted.

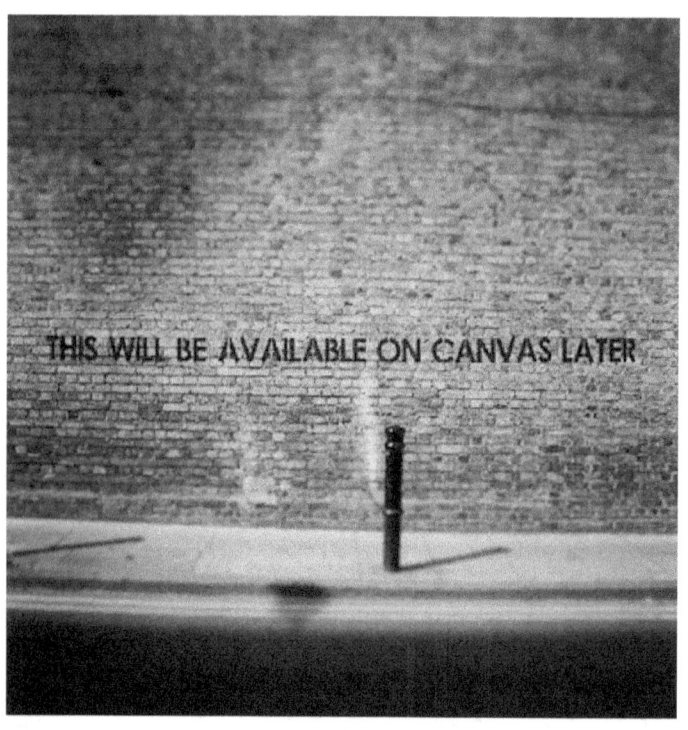

This will be available on canvas later.

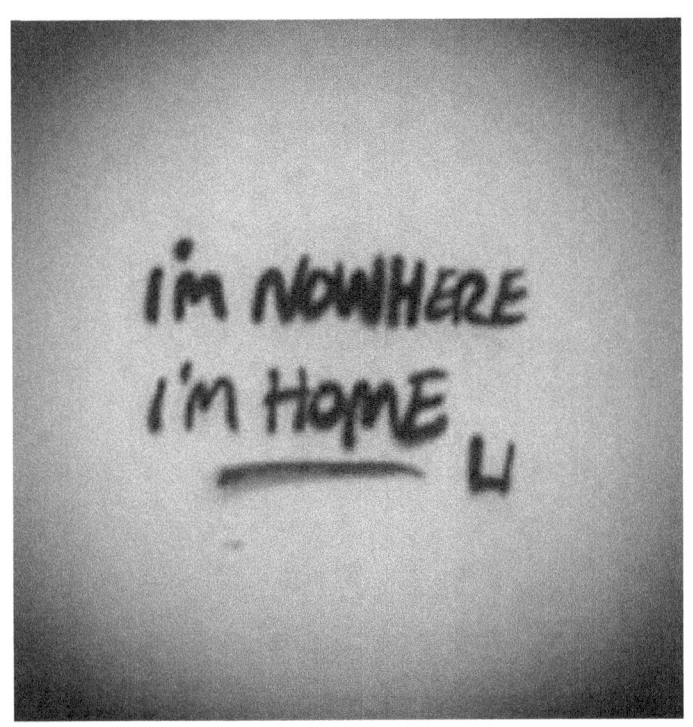

I'm nowhere
I'm home.

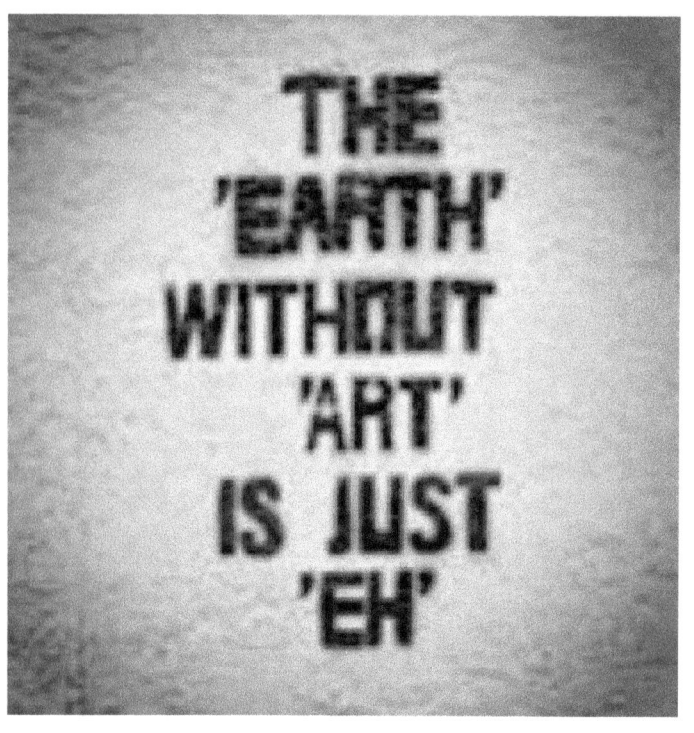

The 'Earth' without 'art' is just 'Eh'.

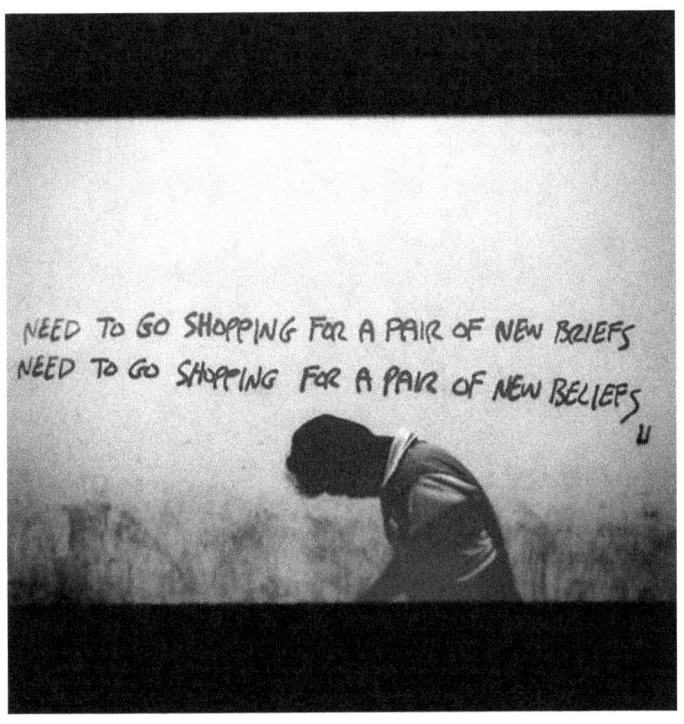

Need to go shopping for a pair of new briefs
Need to go shopping for a pair of new beliefs.

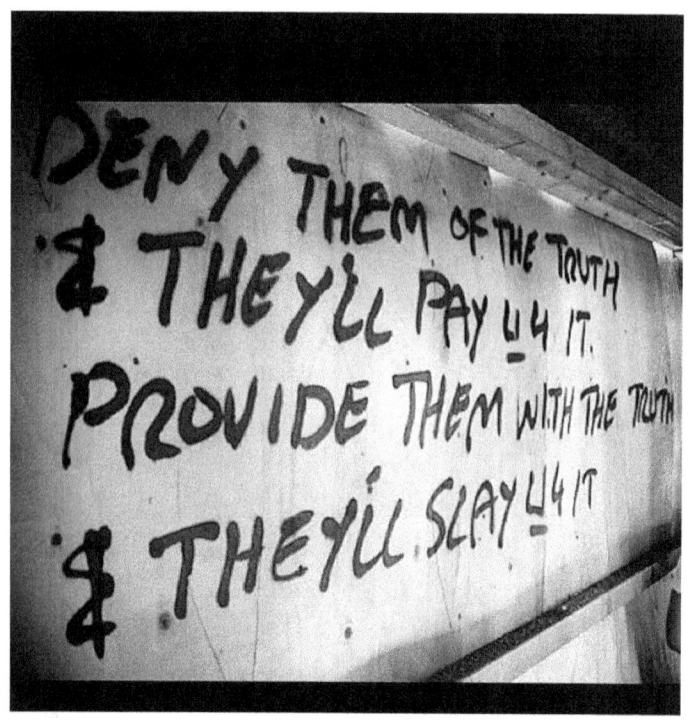

Deny them of the truth and they'll pay you for it.
Provide them with the truth and they'll slay you for it.

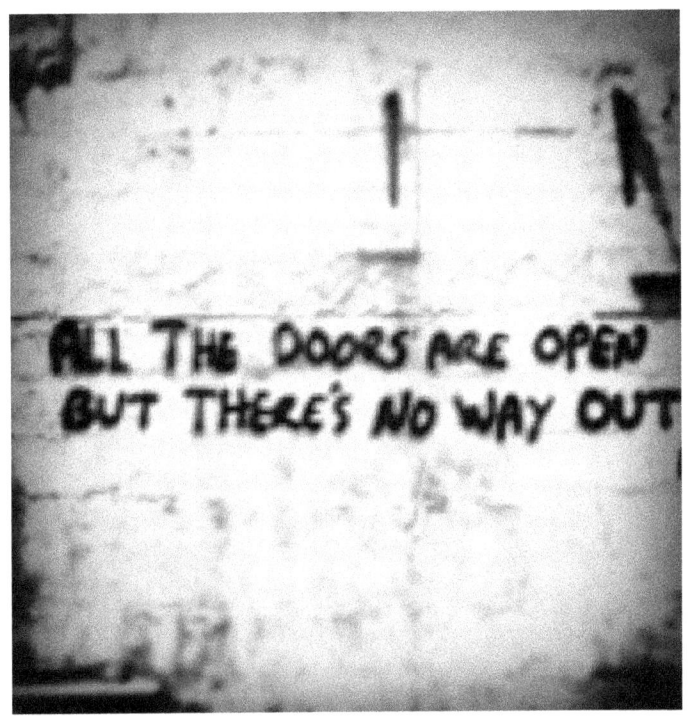

All the doors are open but there's no way out.

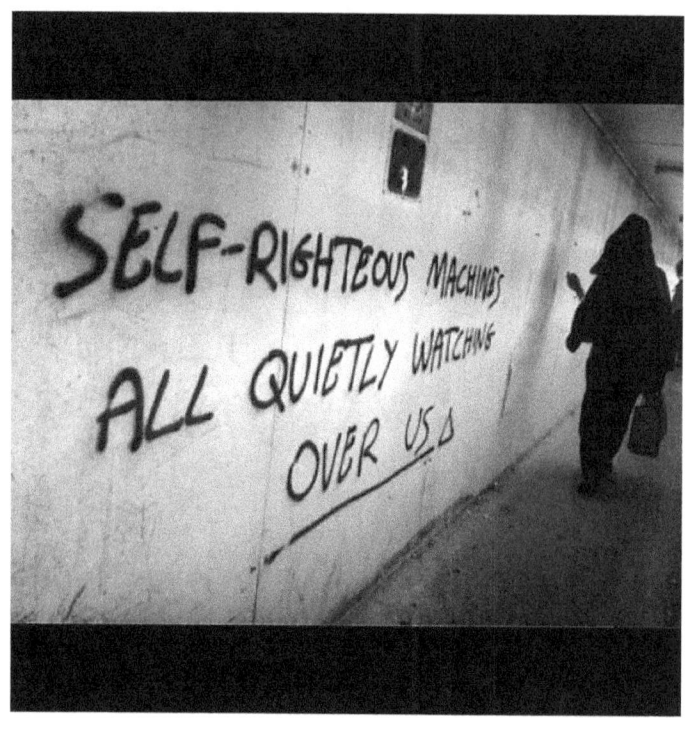

Self-righteous machines all quietly watching over us.

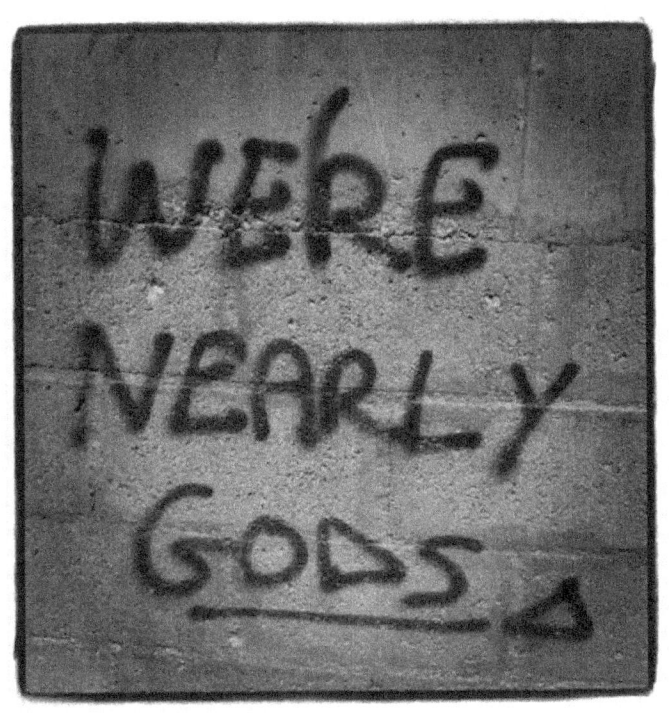

We're nearly Gods.

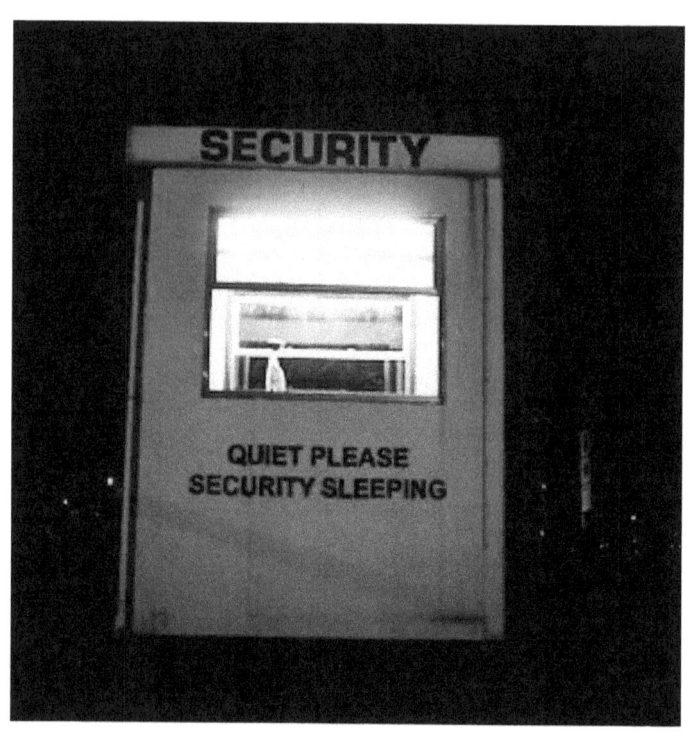

Quiet please. Security sleeping.

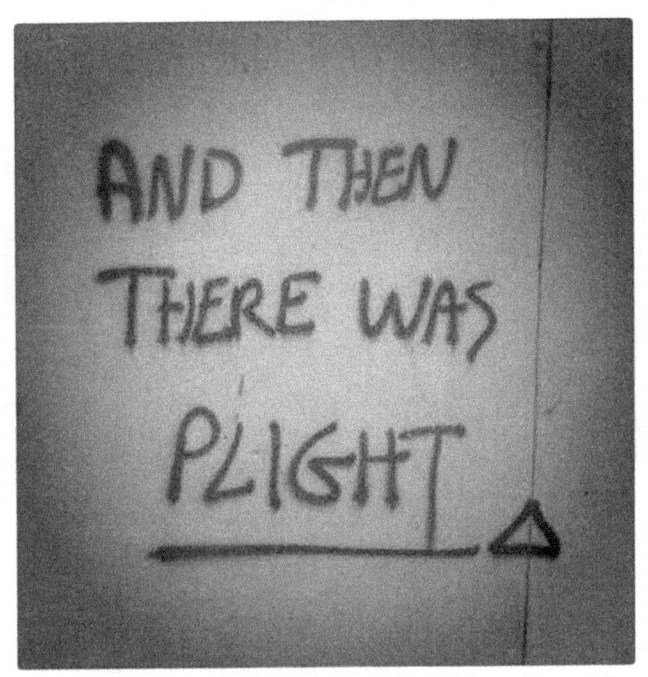

And then there was plight.

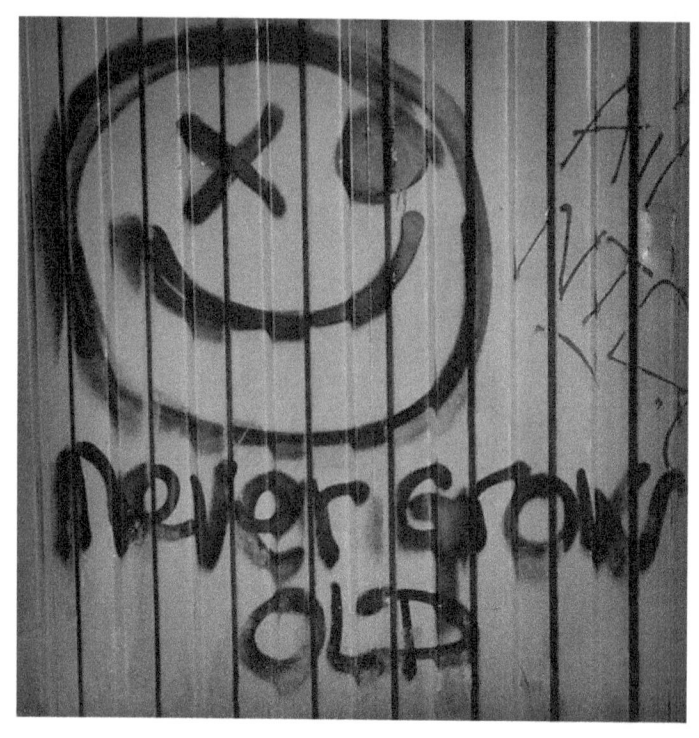

Never grow old.

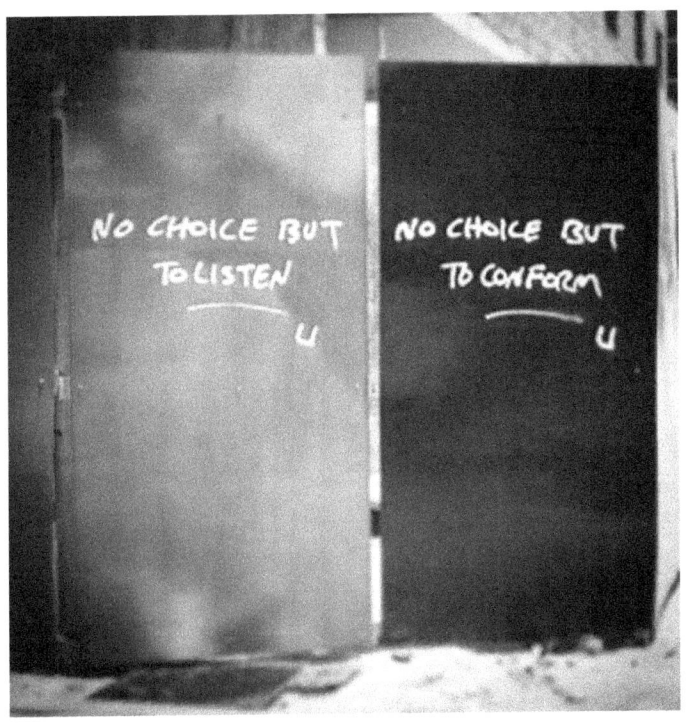

No choice but to listen.
No choice but to conform.

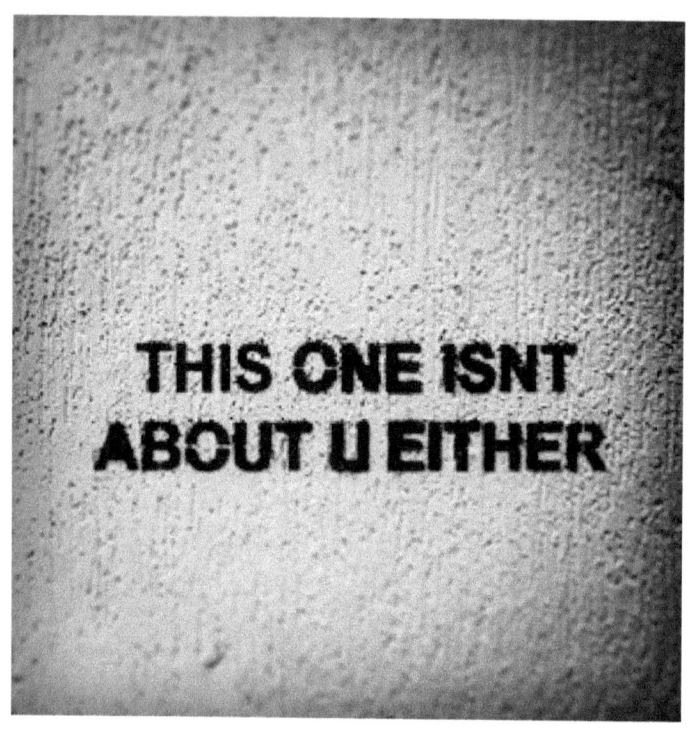

This one isn't about you either.

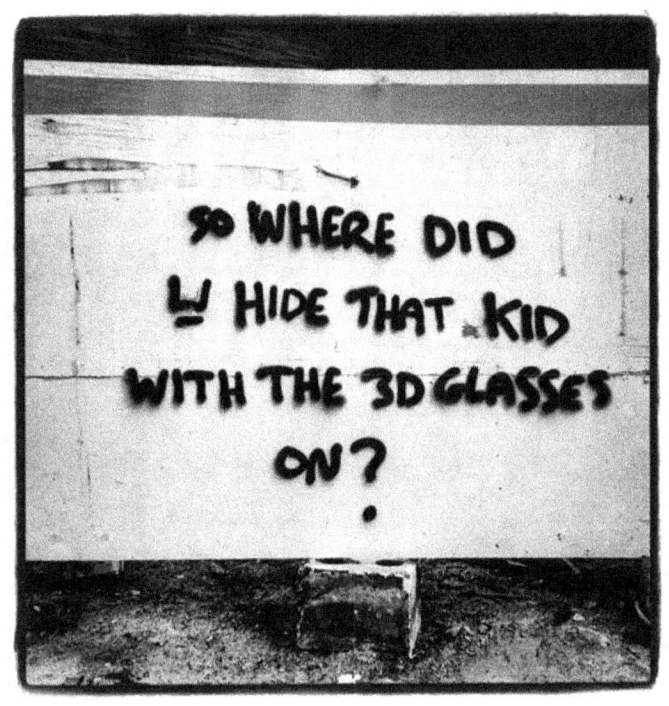

So, where did you hide that kid with the 3D glasses on?

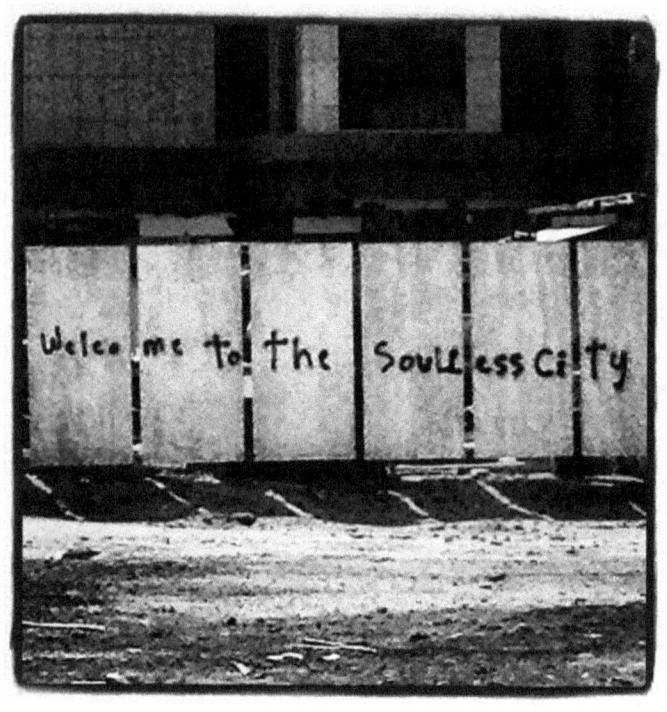

Welcome to the soulless city.

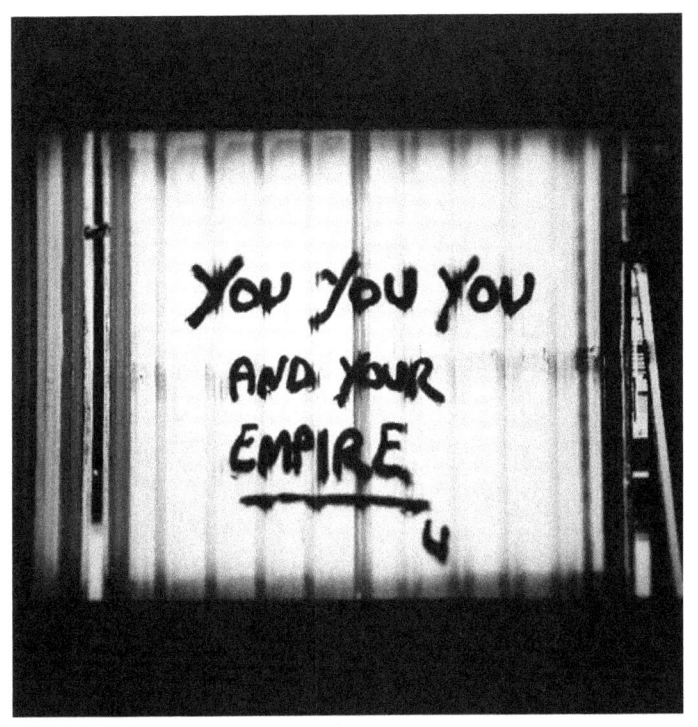

You, you, you and your empire.

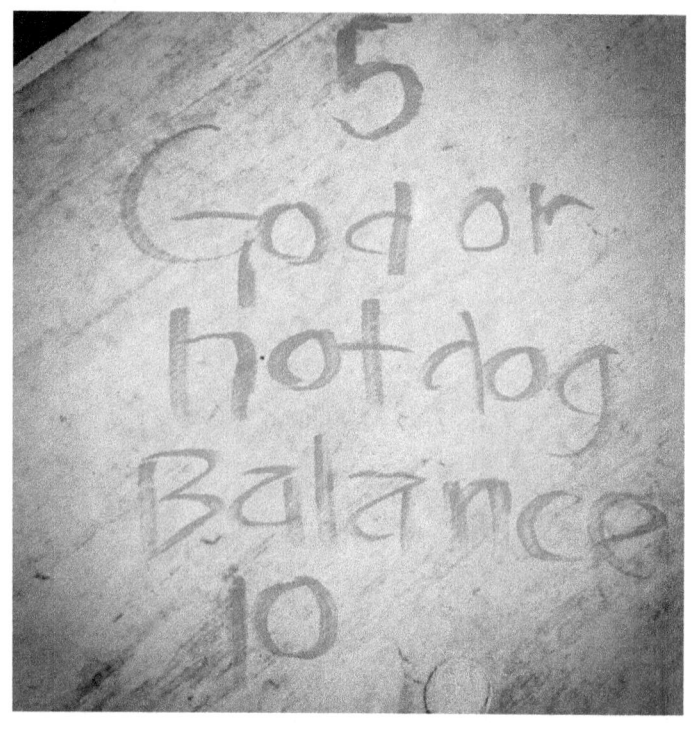

God or hotdog balance – 5-10.

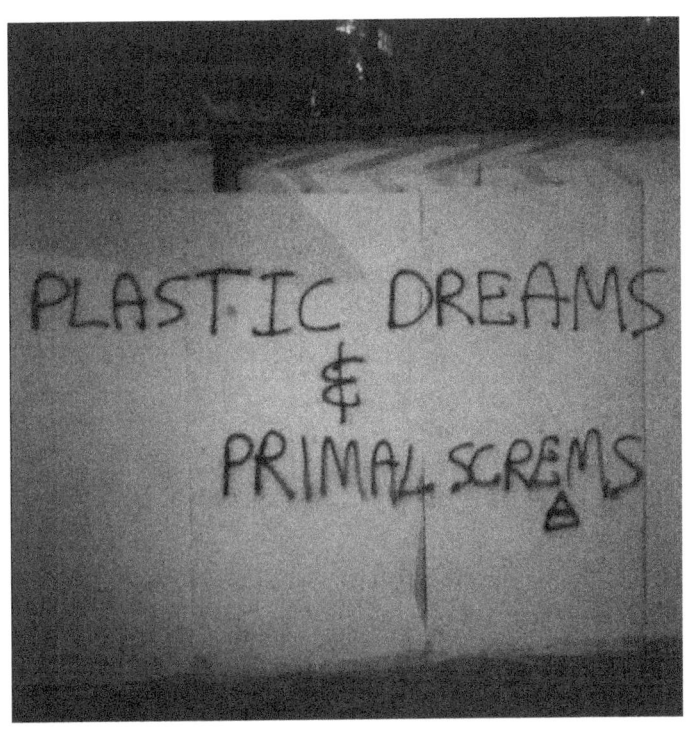

Plastic dreams & primal screams.

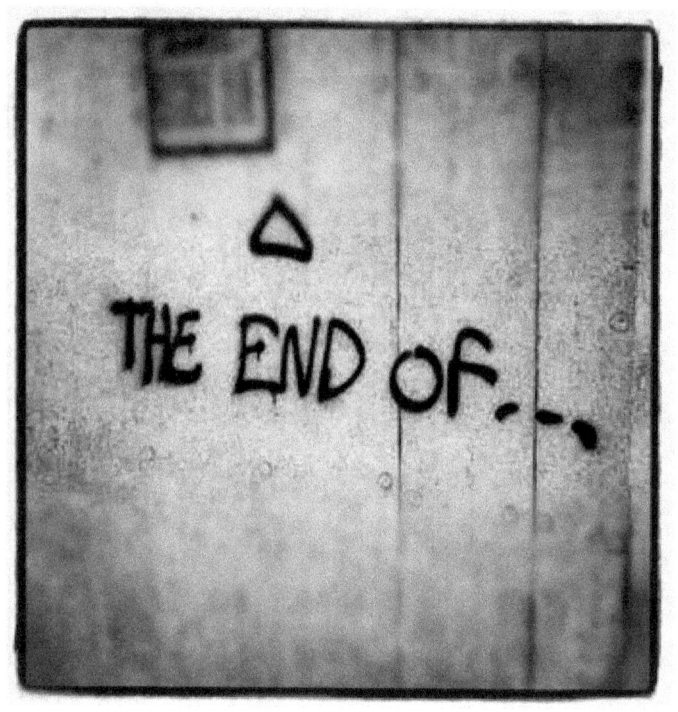

The end of...

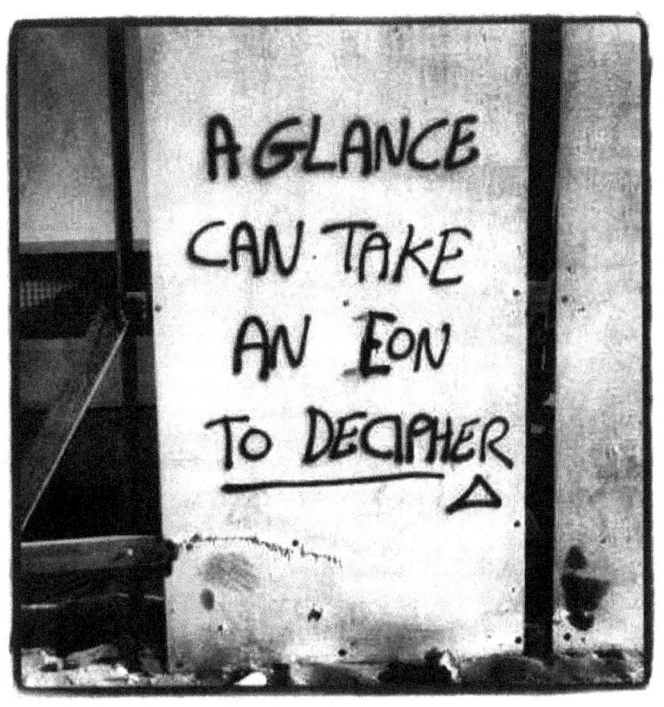

A glance can take an Eon to decipher.

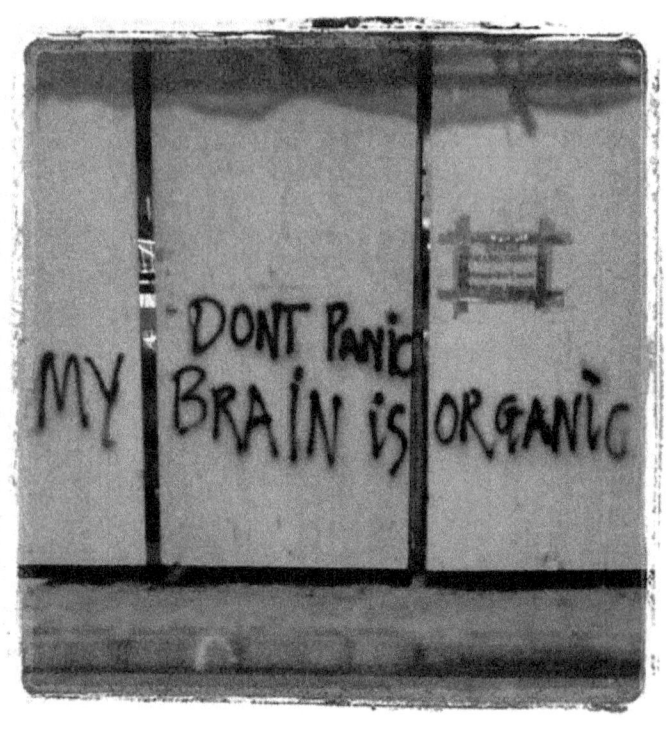

Don't panic my brain is organic.

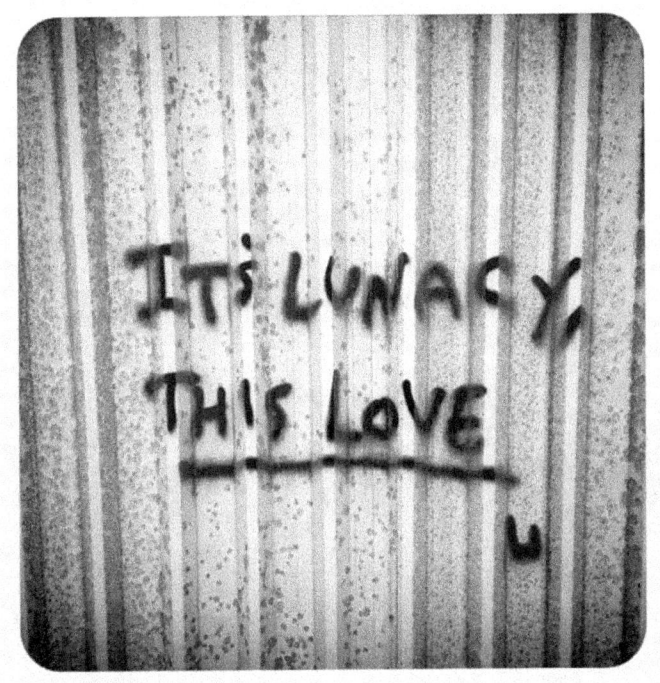

It's lunacy this love.

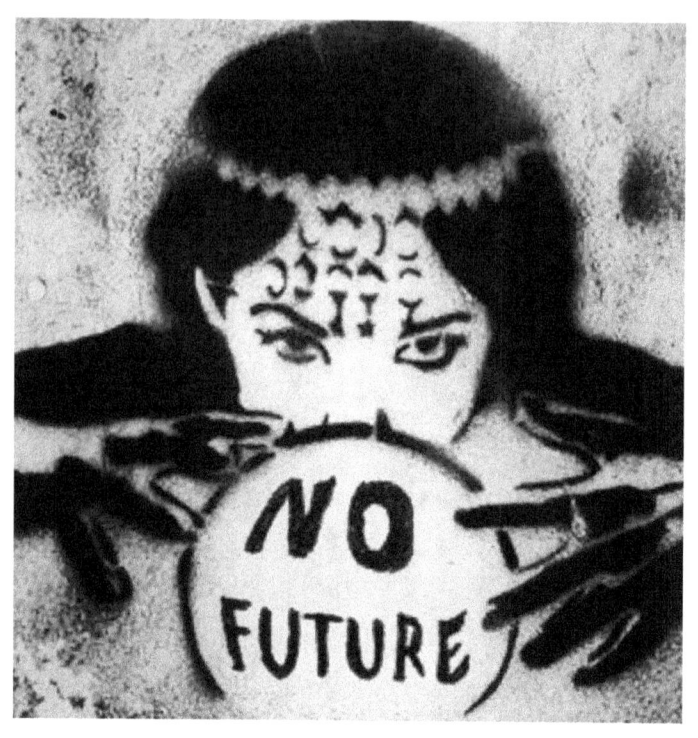

No future.

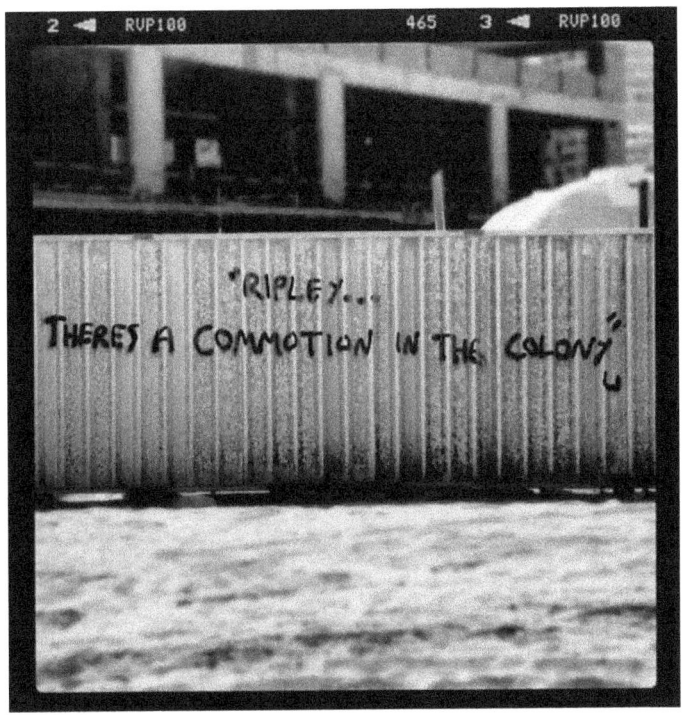

"Ripley… There's a commotion in the colony".

So, how's things out there?

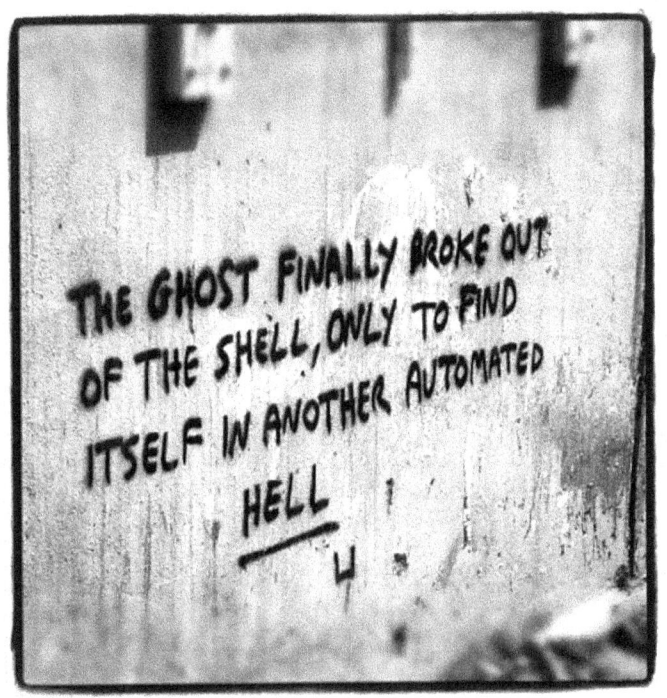

The ghost finally broke out of the shell, only to find itself in another automated hell.

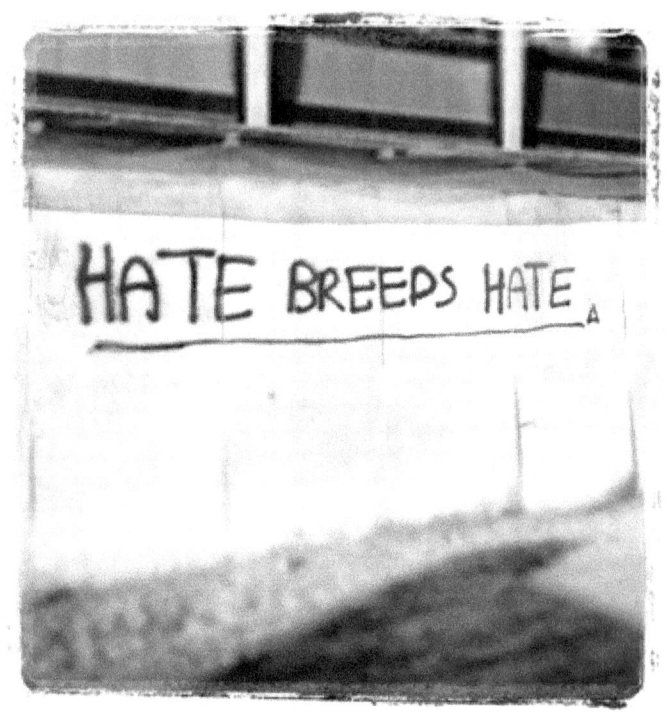

Hate breeds hate.

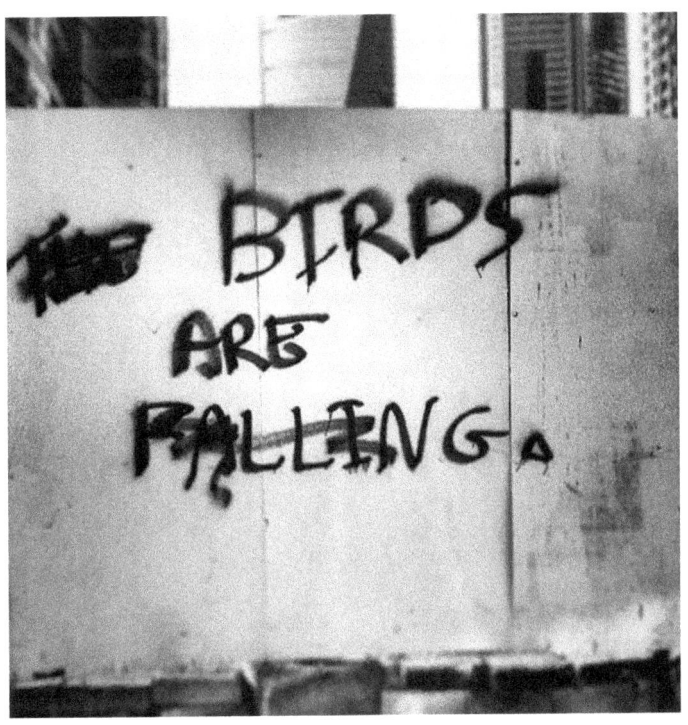

The birds are falling.

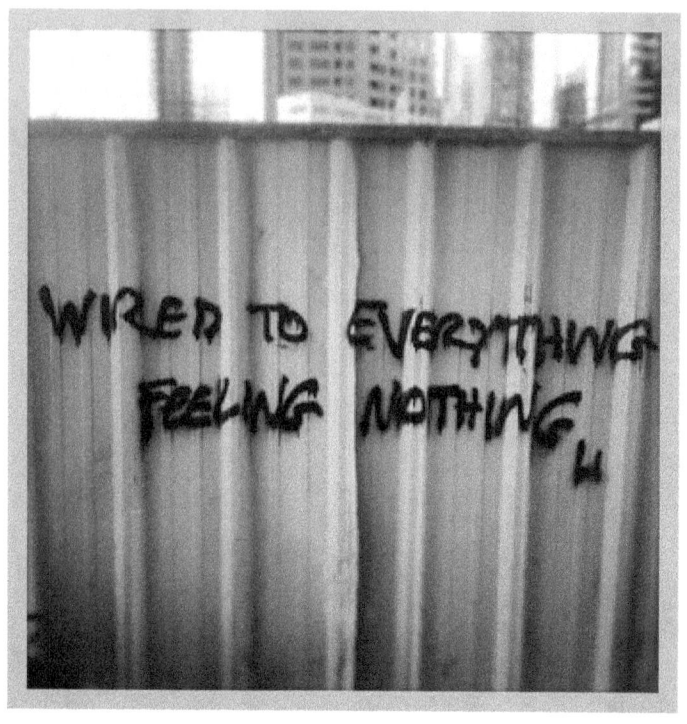

Wired to everything, feeling nothing.

Sterile to a whole new degree of toxicity.

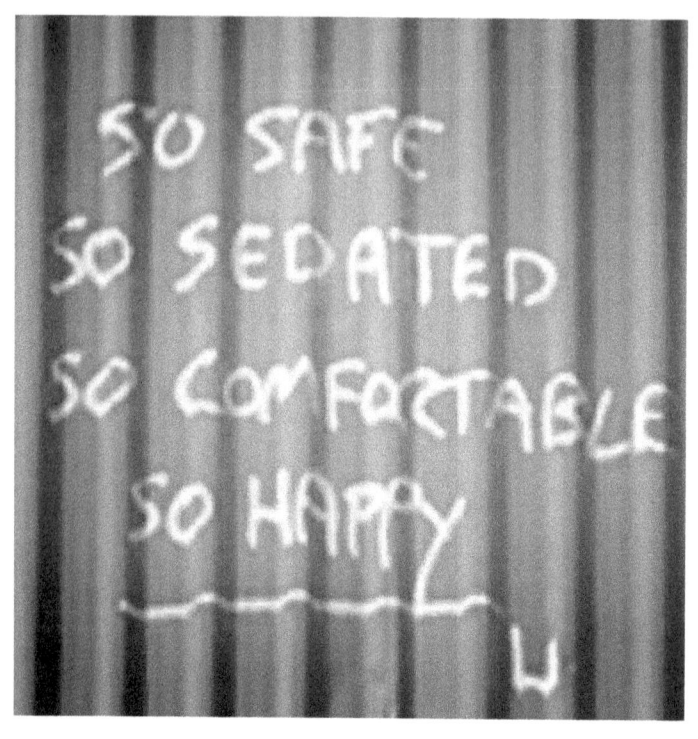

So safe, so sedated, so comfortable, so happy.

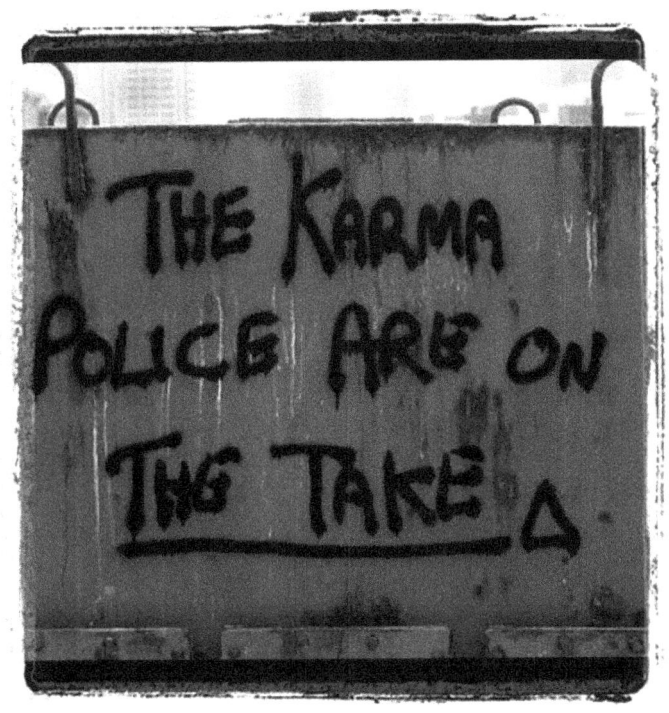

The Karma Police are on the take.

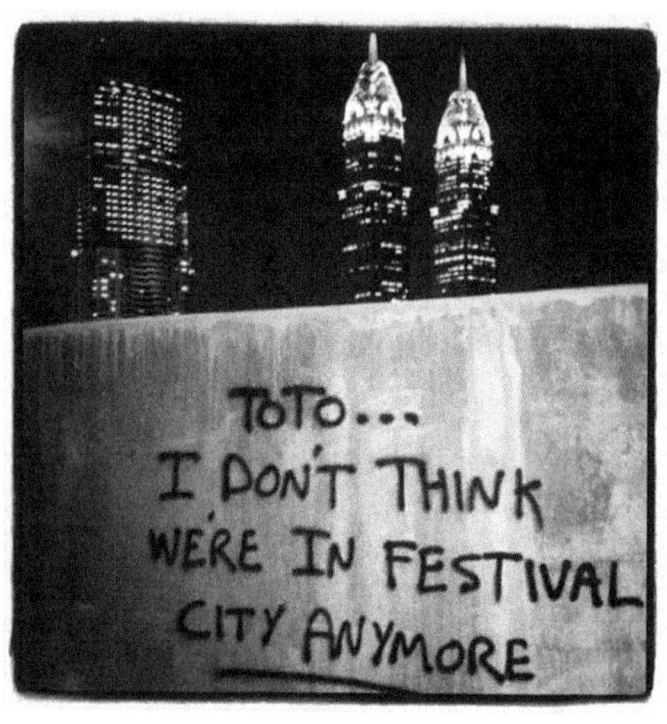

Toto… I don't think we're in Festival City anymore.

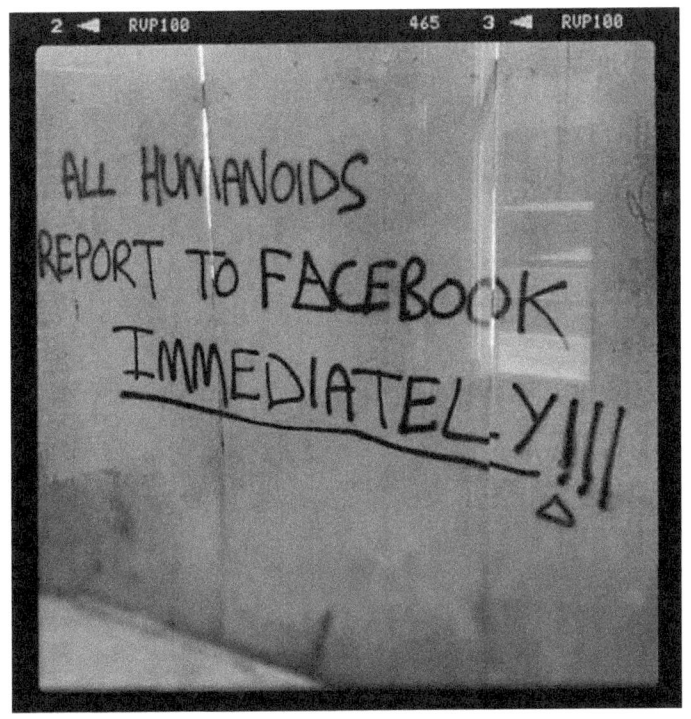

All humanoids report to Facebook immediately!

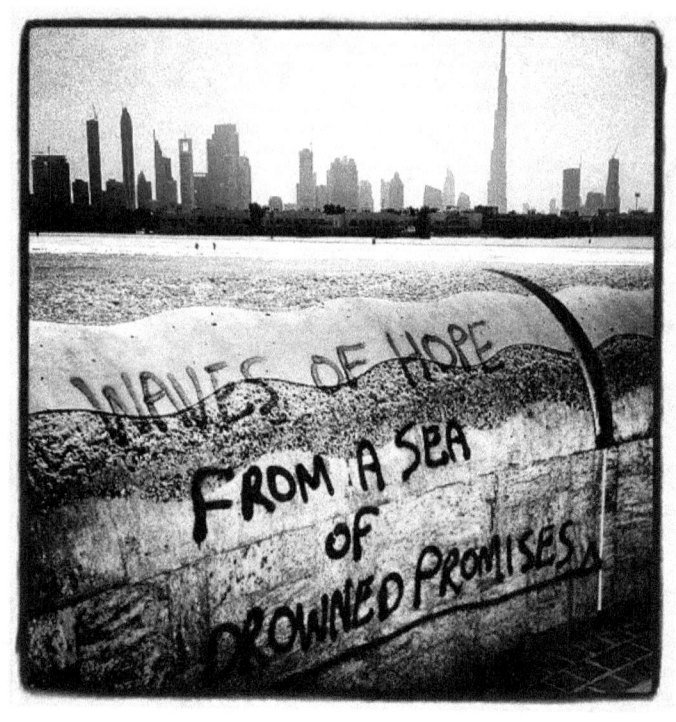

Waves of hope from a sea of drowned promises.

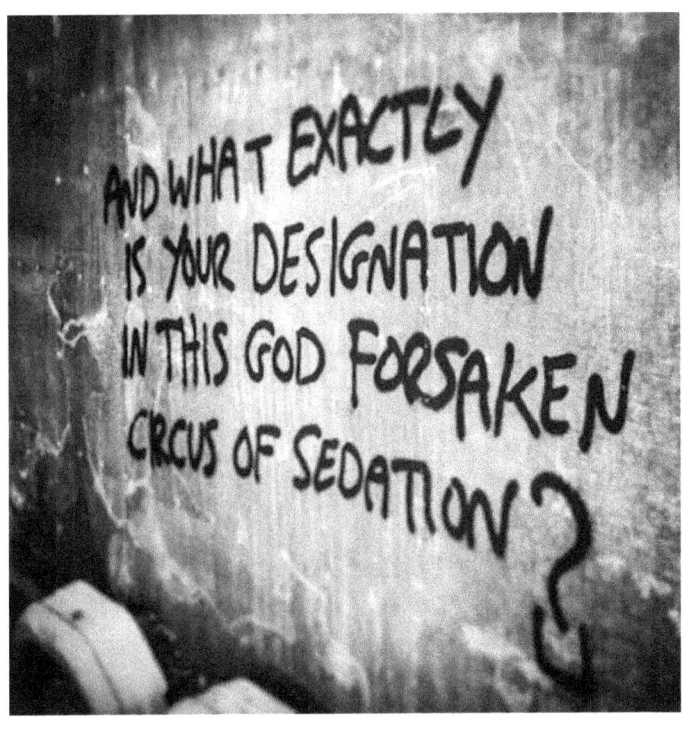

And what exactly is your designation
In this God forsaken circus of sedation?

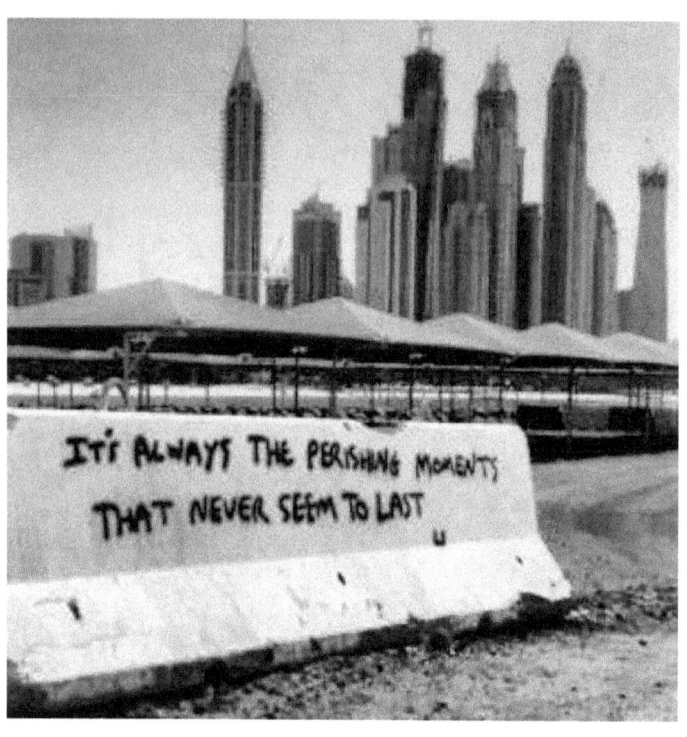

It's the perishing moments that never seem to last.

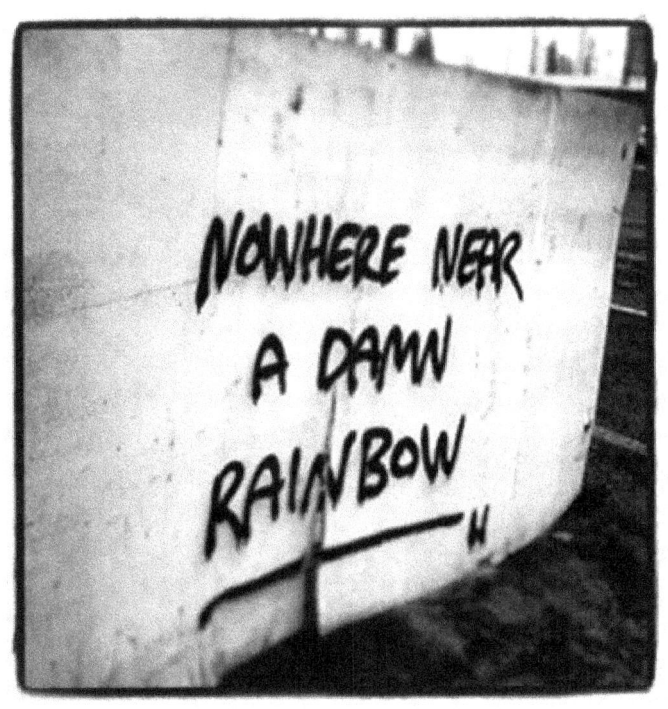

Nowhere near a damn rainbow.

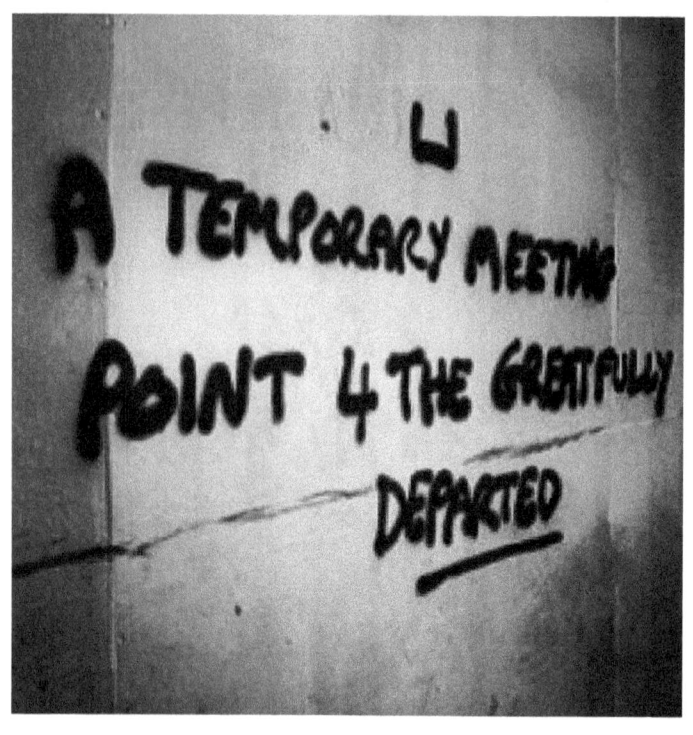

A temporary meeting point for the gratefully departed.

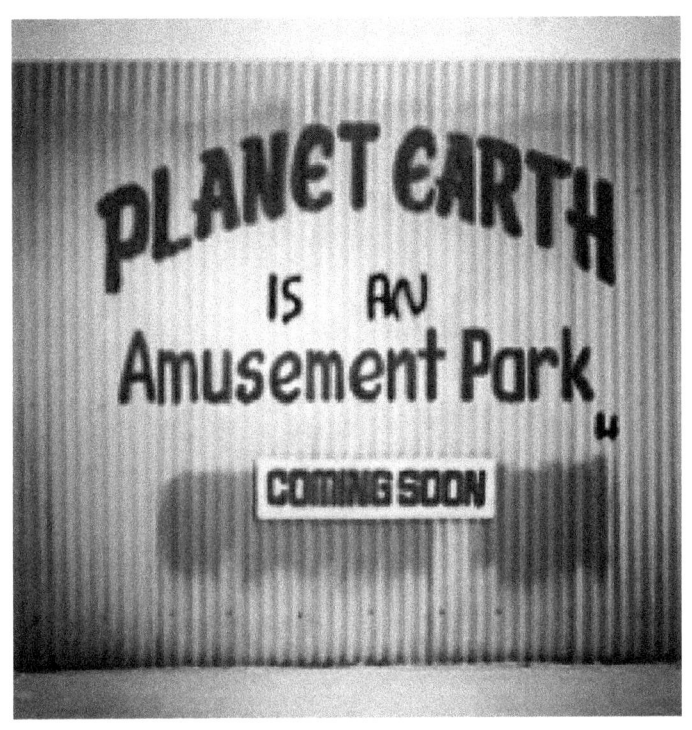

Planet Earth is an amusement park.

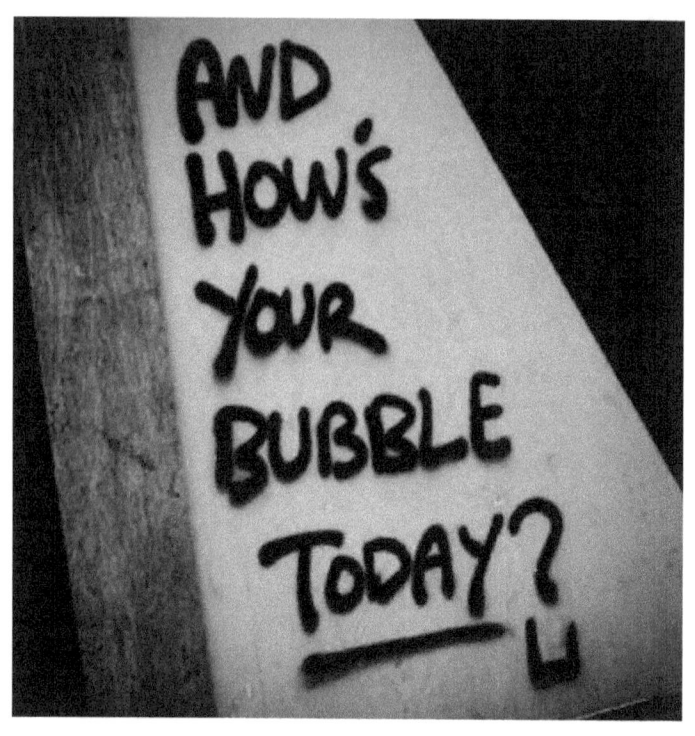

And how's your bubble today?

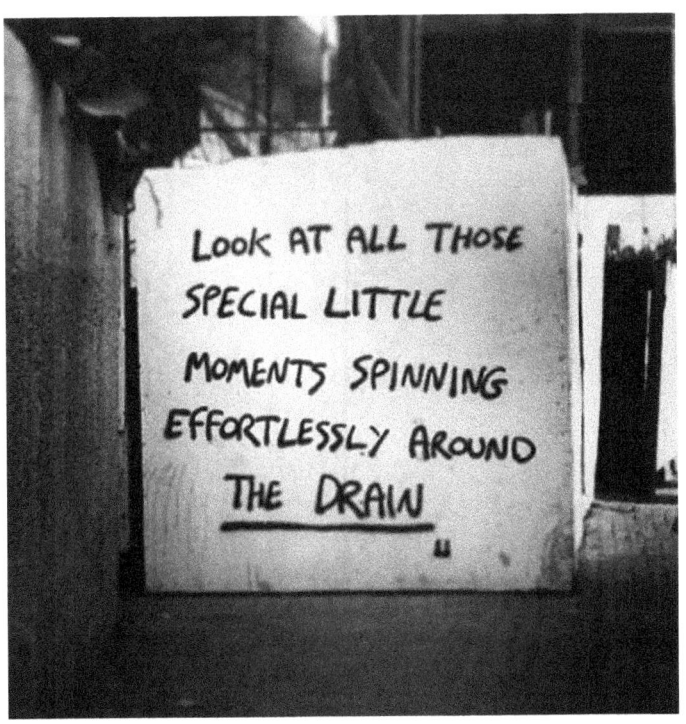

Look at all those special little moments spinning effortlessly around the draw.

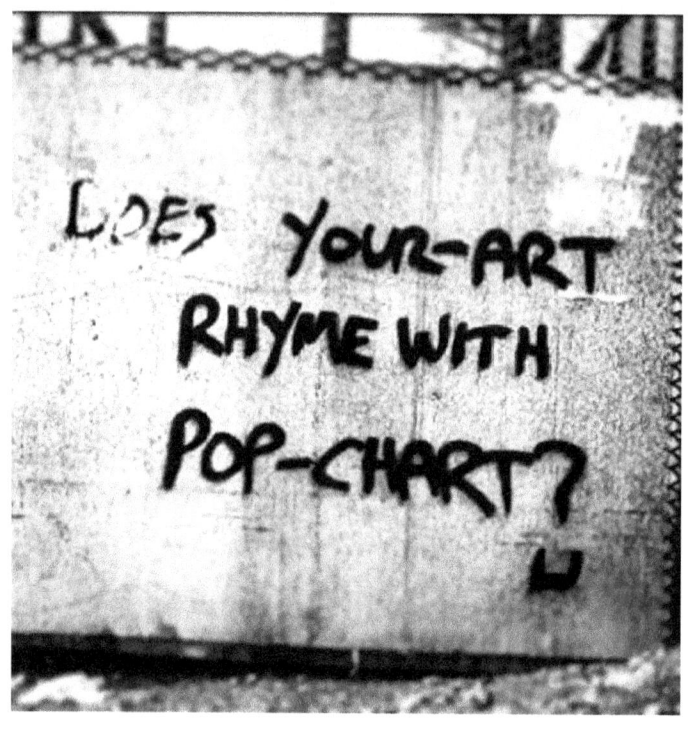

Does your-art rhyme with pop-chart?

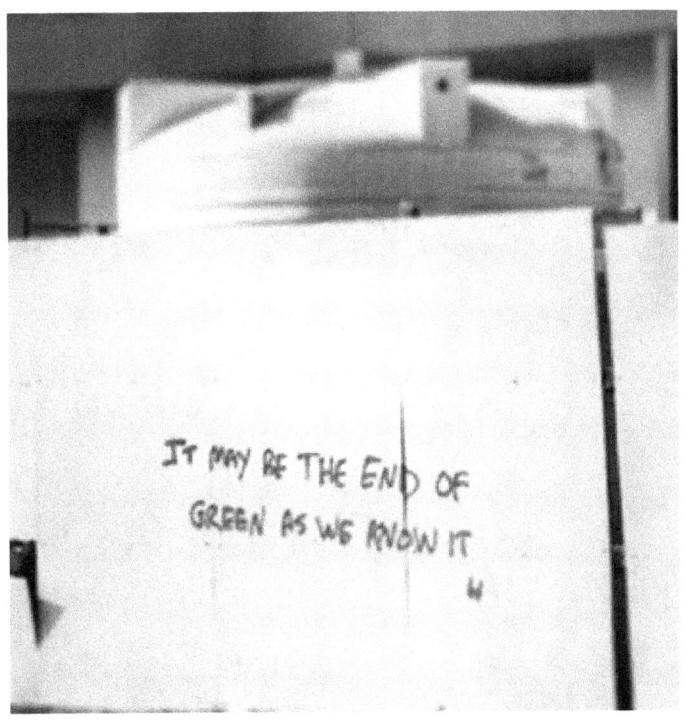

It may be the end of green, as we know it.

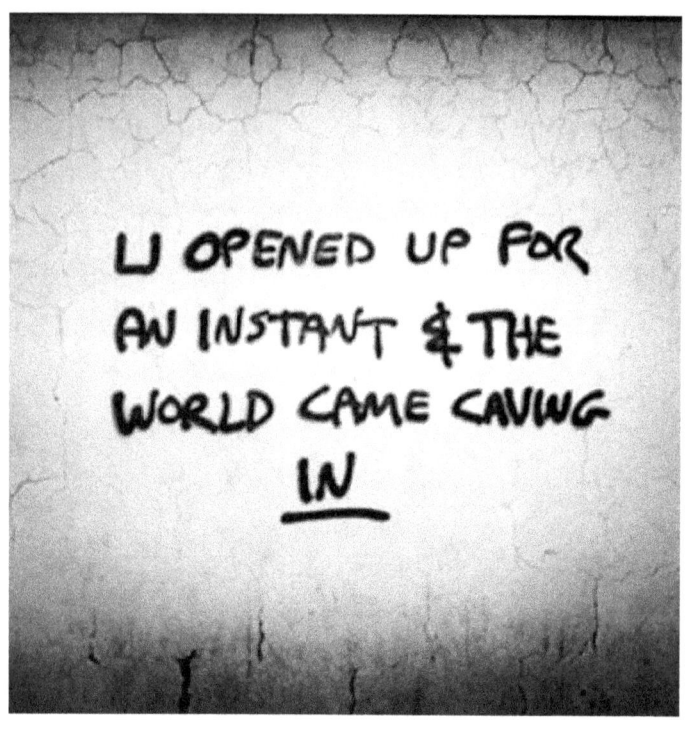

You opened up for an instant and the world came caving in.

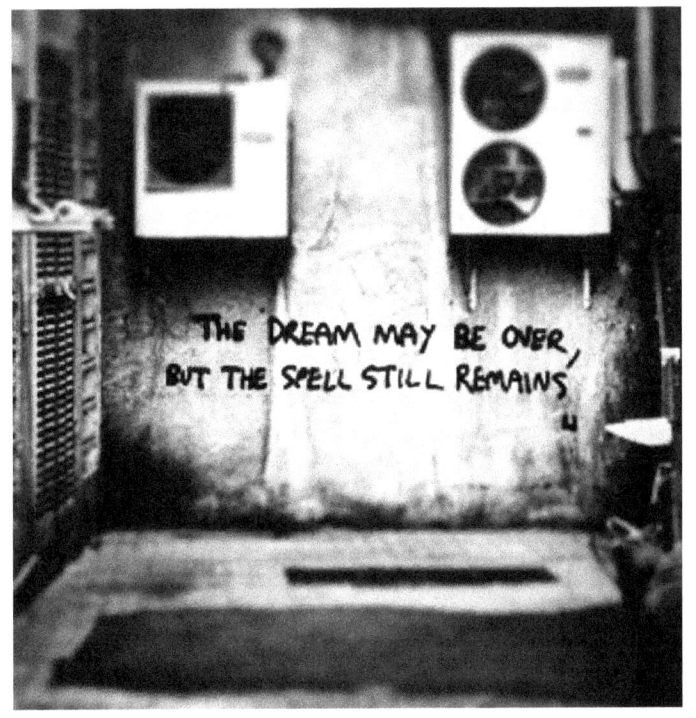

The dream may be over, but the spell still remains.

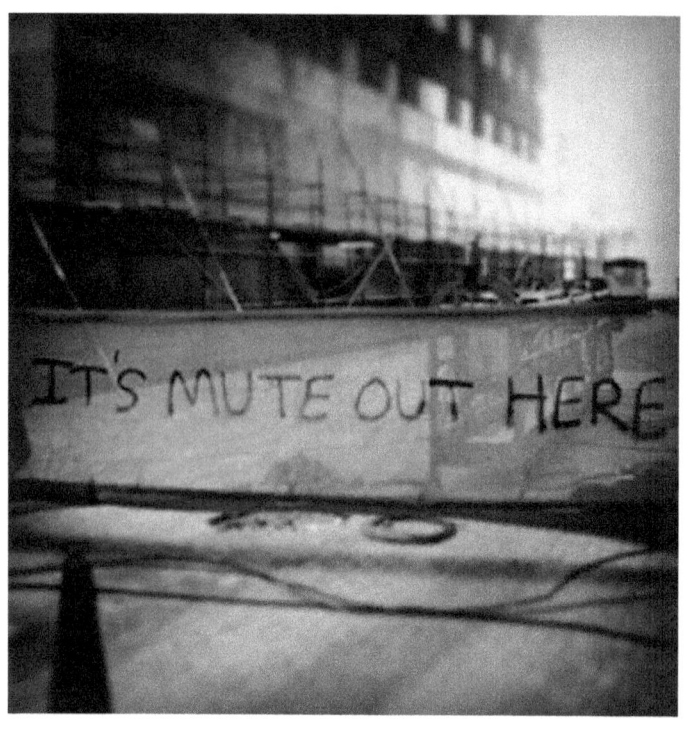

It's mute out here.

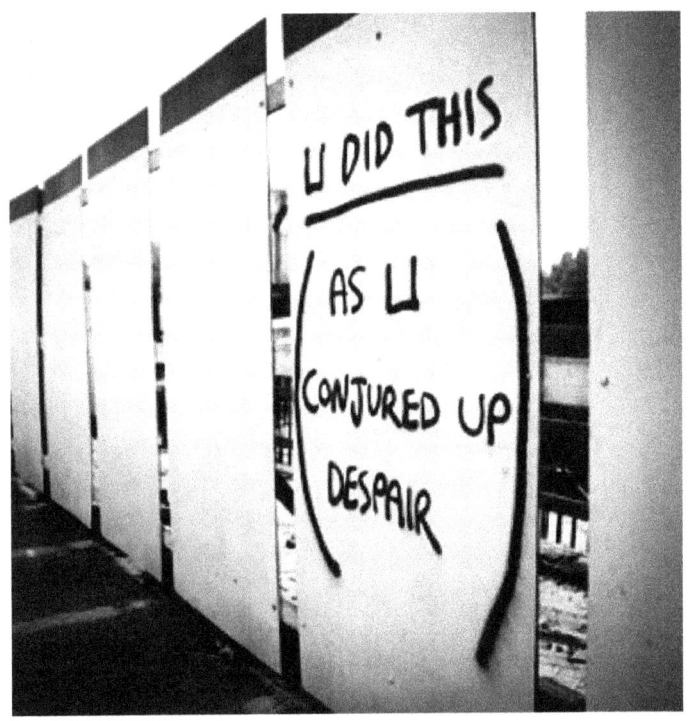

You did this (as you conjured up despair).

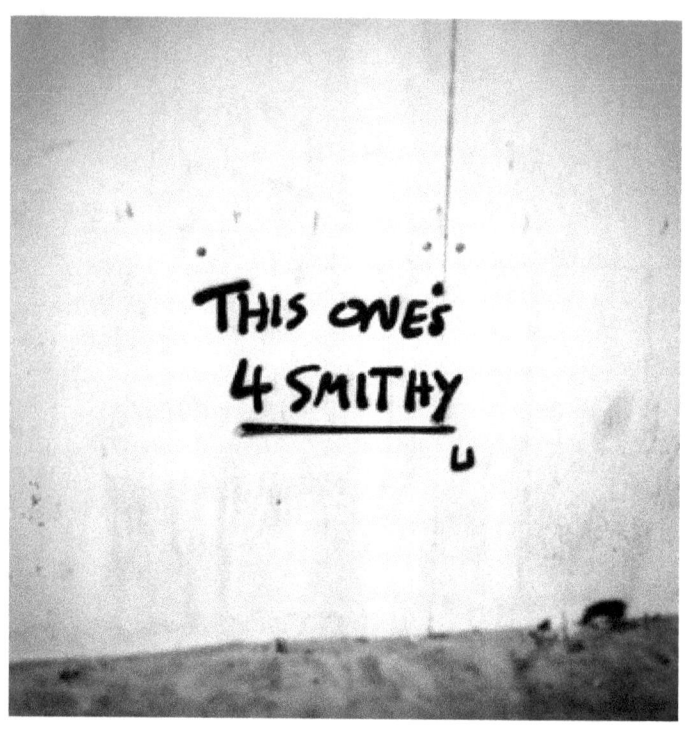

This one's for Smithy.

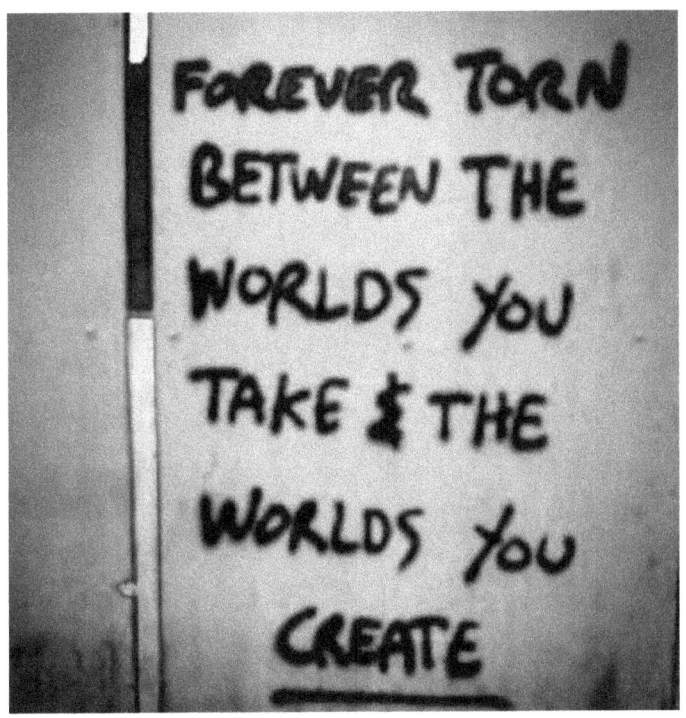

Forever torn between the worlds you take and the worlds you create.

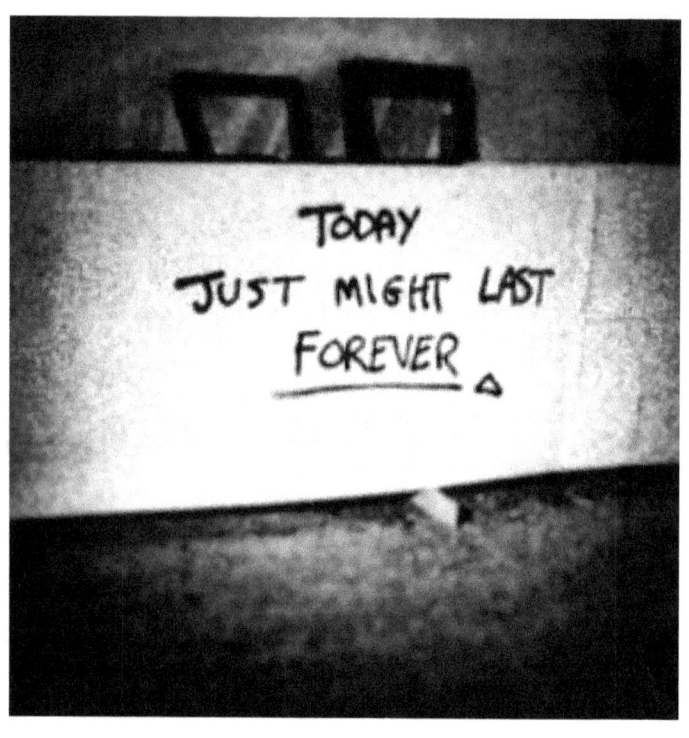

Today just might last forever.

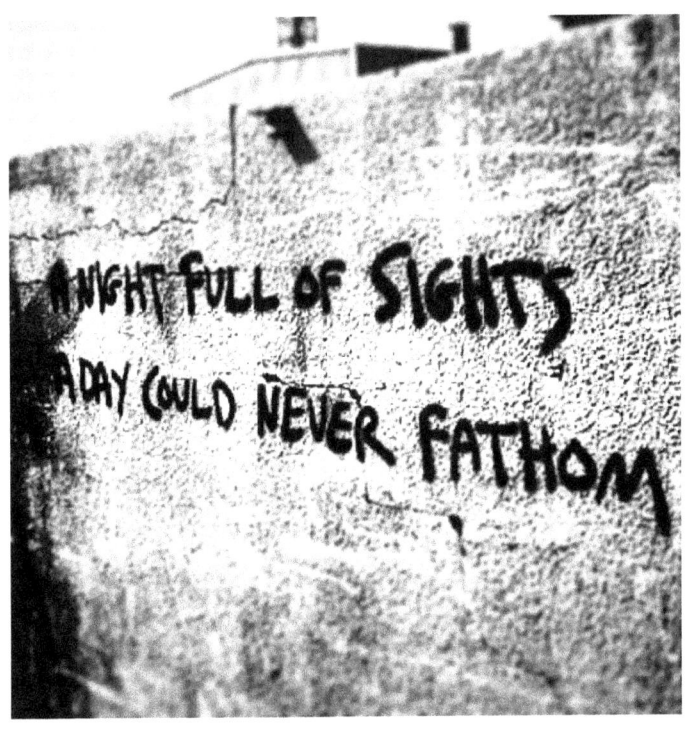

A night full of sights a day could only fathom.

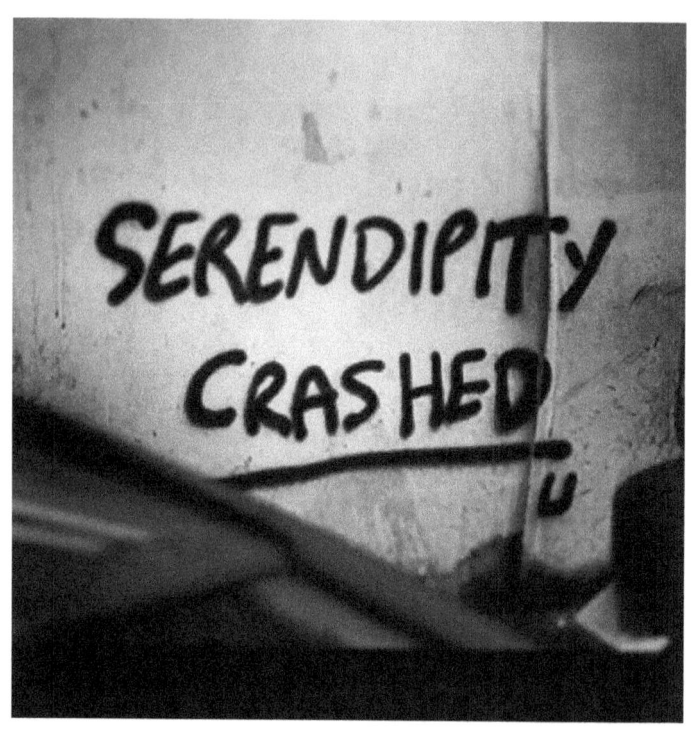

Serendipity crashed.

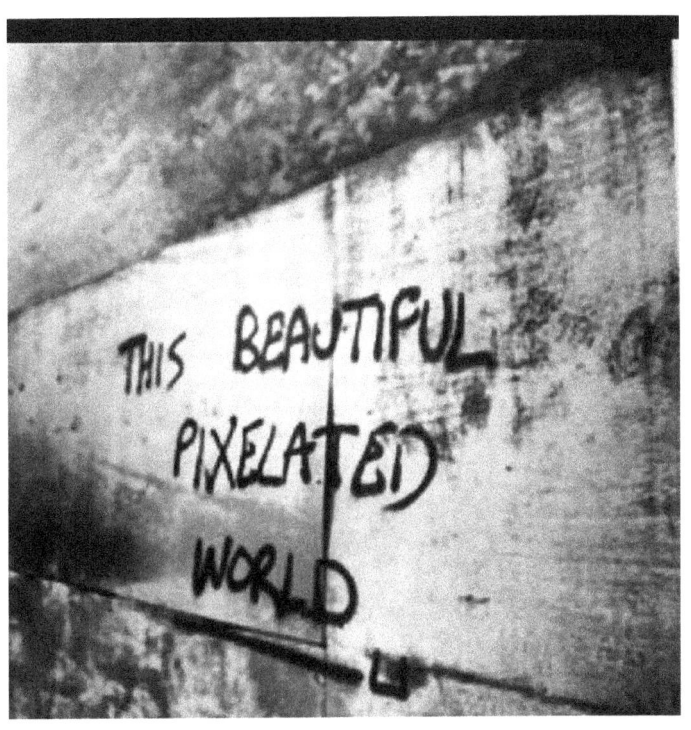

This beautiful pixelated world.

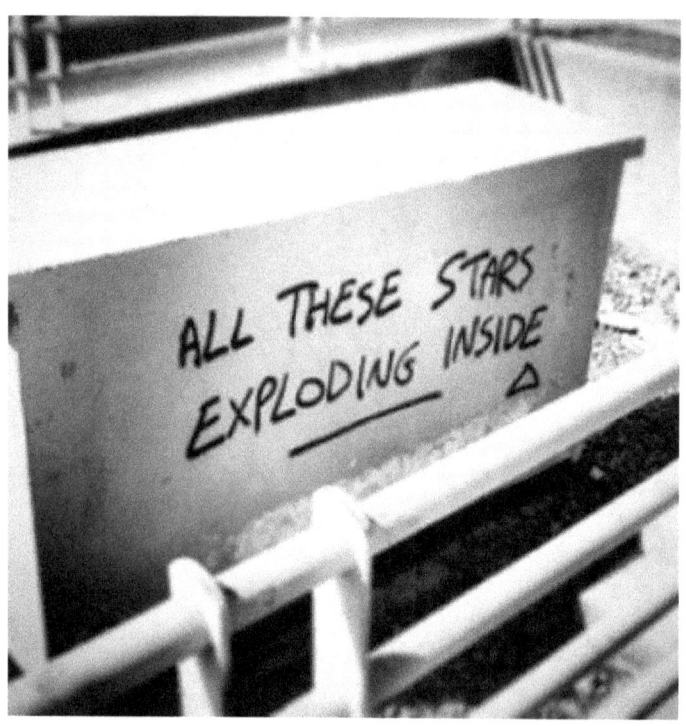

All these stars exploding inside.

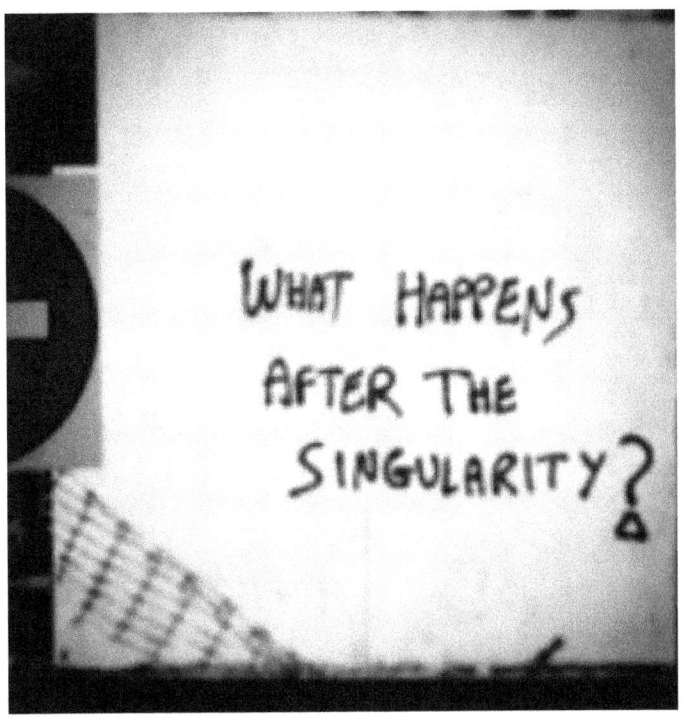

What happens after the singularity?

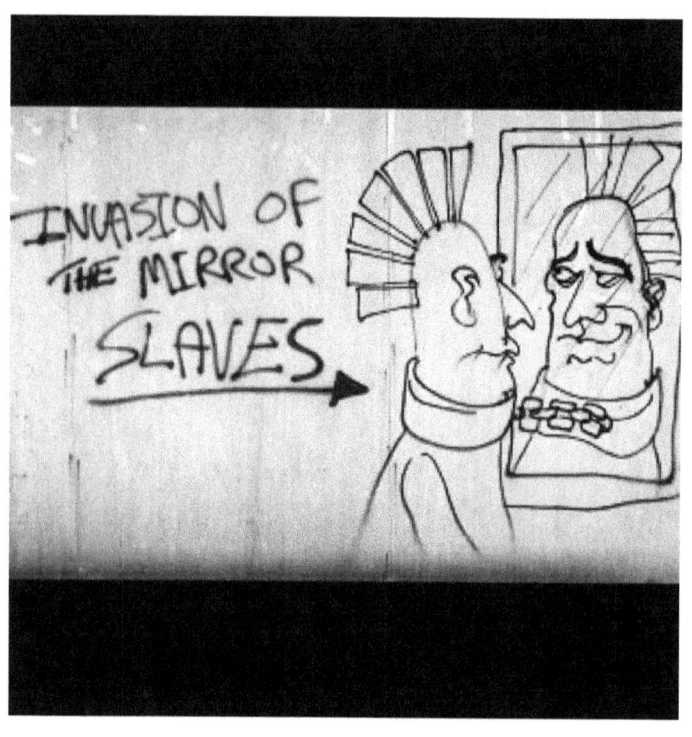

Invasion of the mirror slaves.

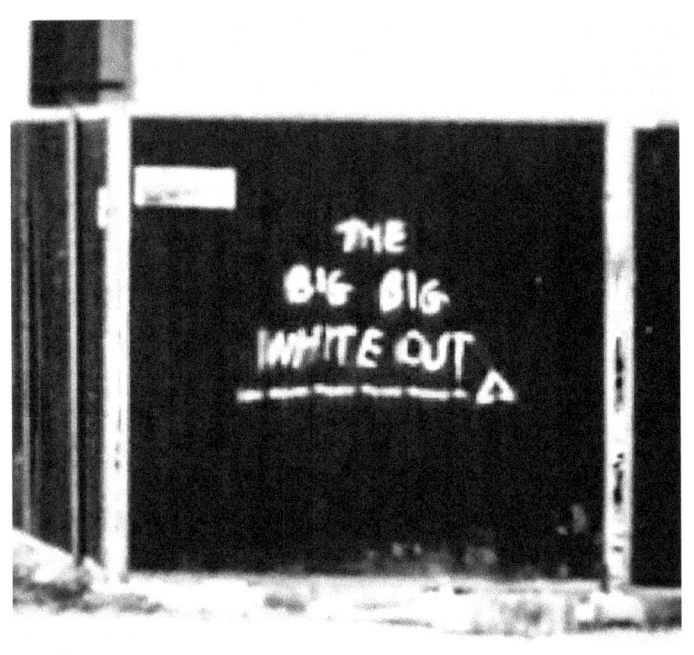

The big, big white out.

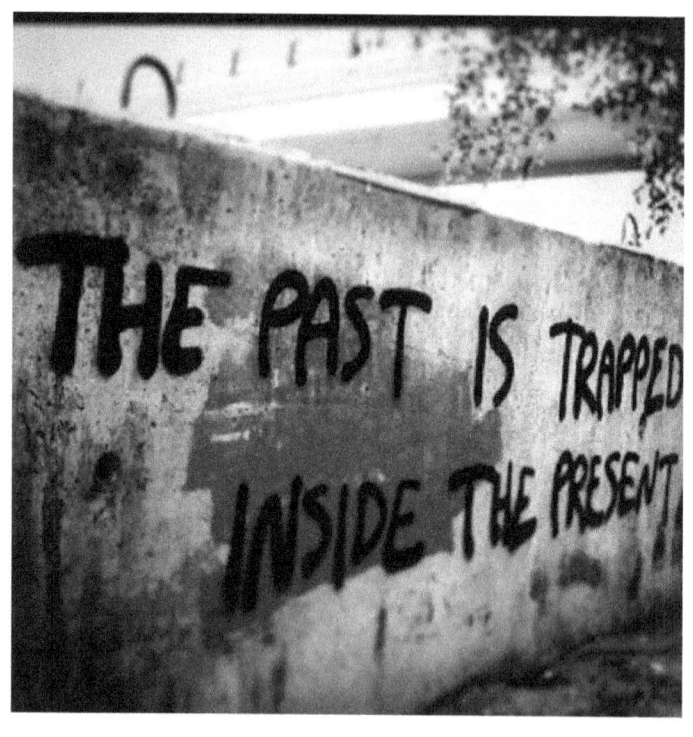

The past is trapped inside the present.

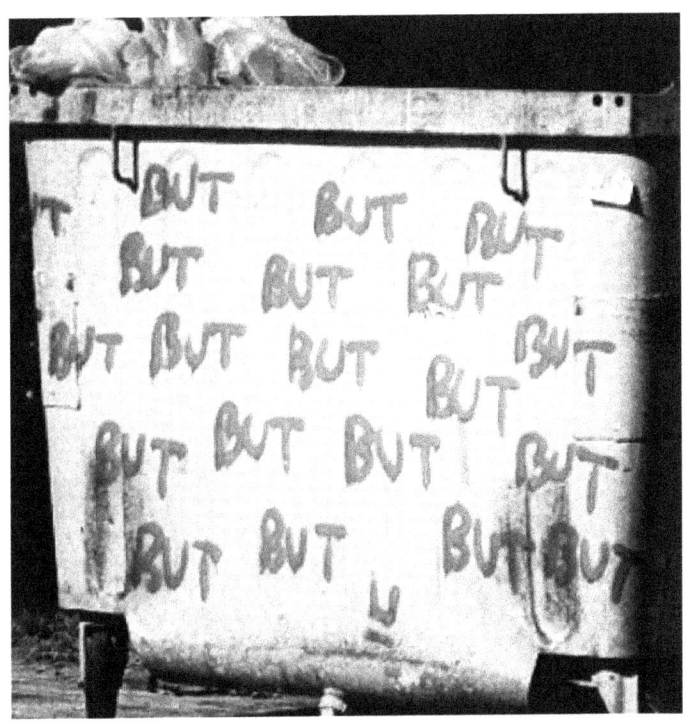

But, but, but…

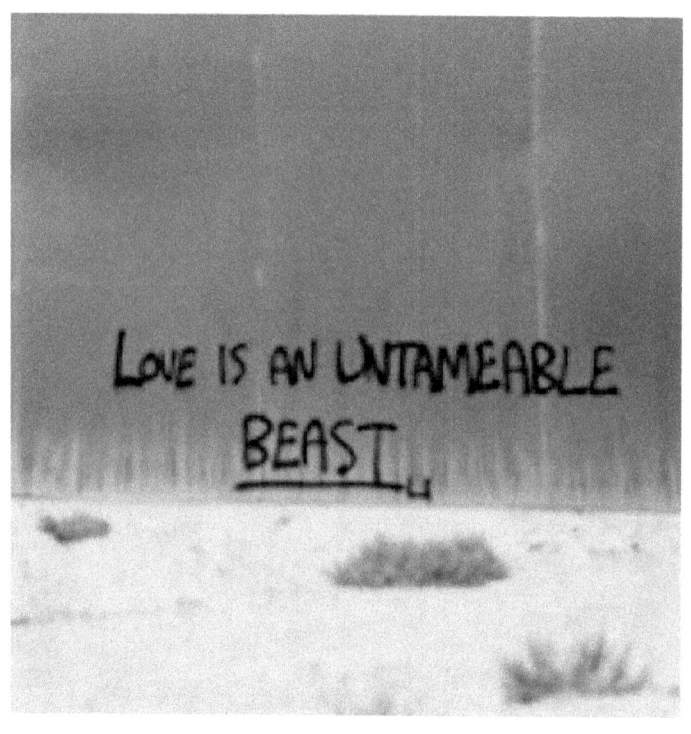

Love is an untameable beast.

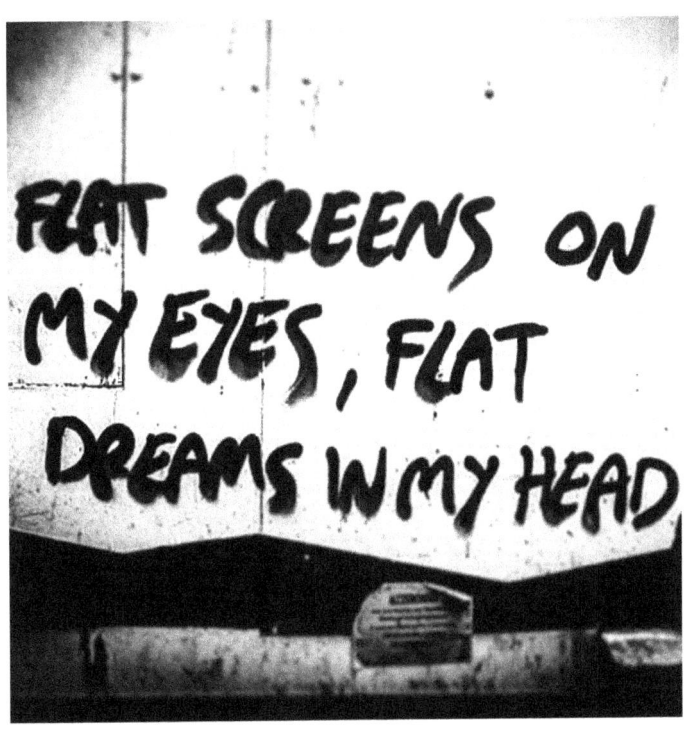

Flat screens on my eyes, flat dreams in my head.

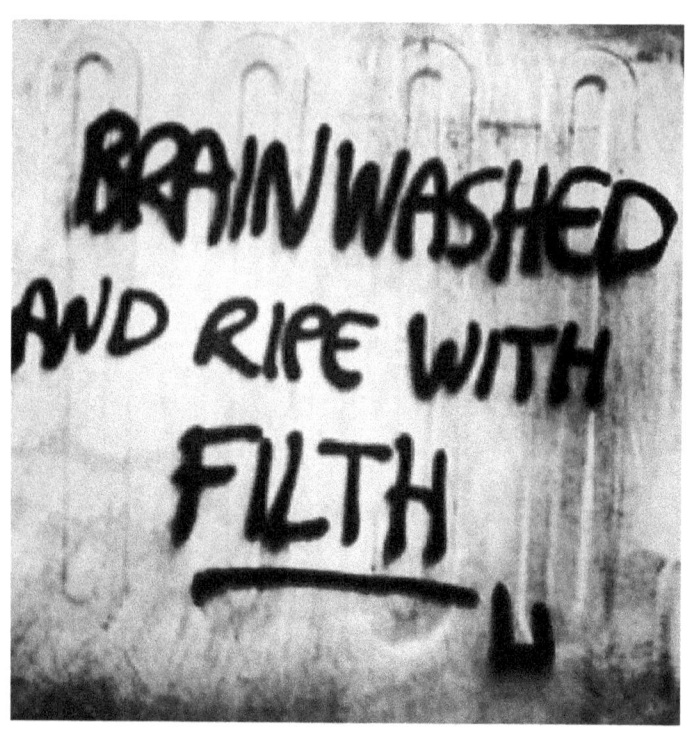

Brainwashed and ripe with filth.

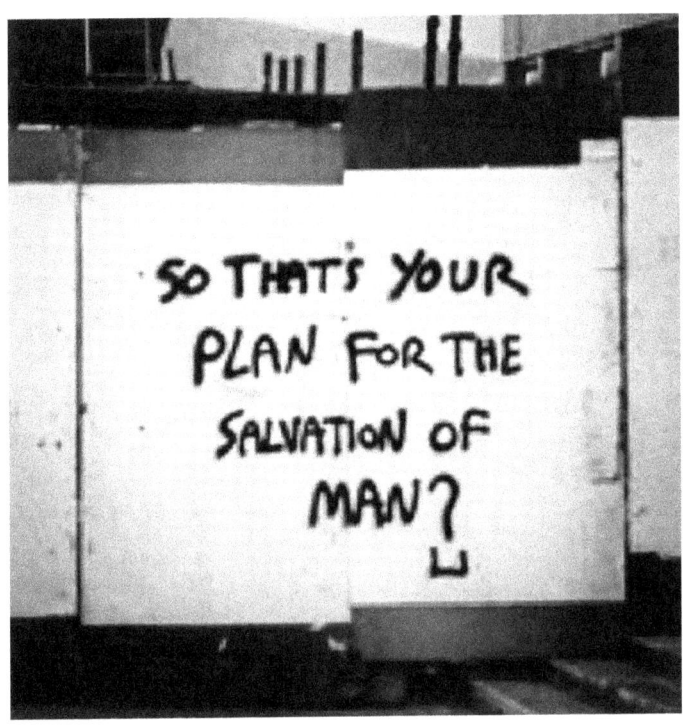

So that's your plan for the salvation of man?

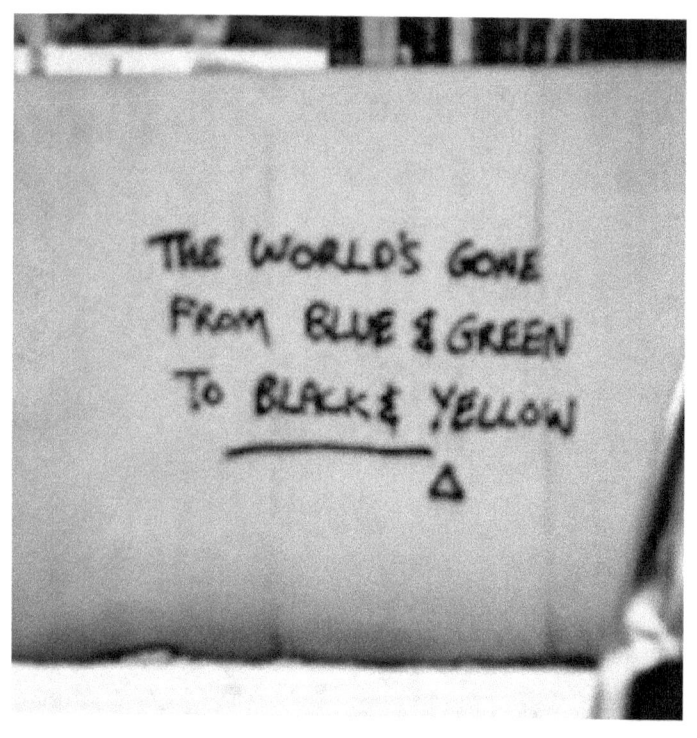

The world's gone from blue & green to black & yellow.

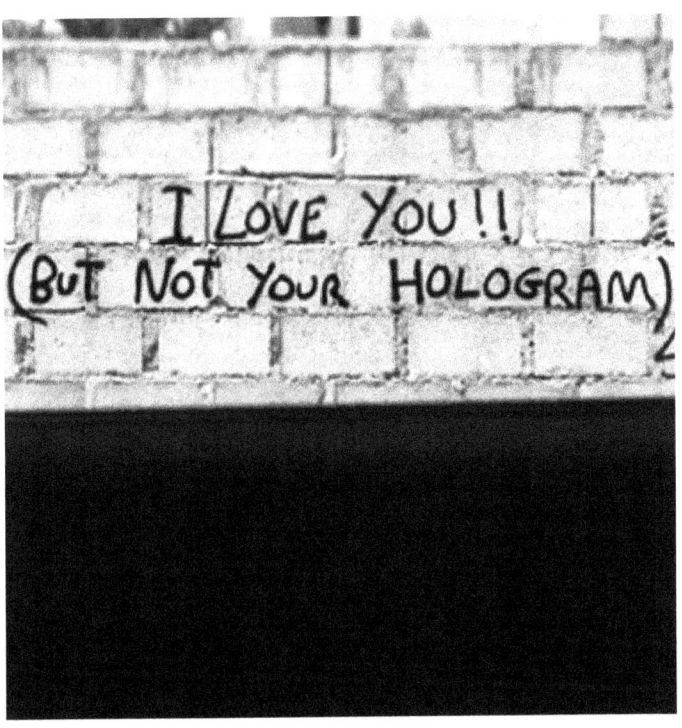

I love you! (But not your hologram).

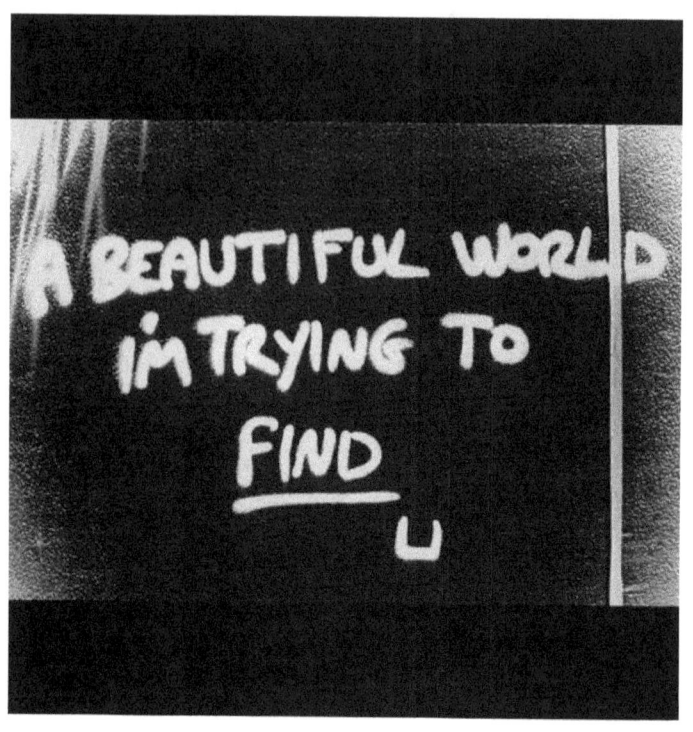

A beautiful world I'm trying to find.

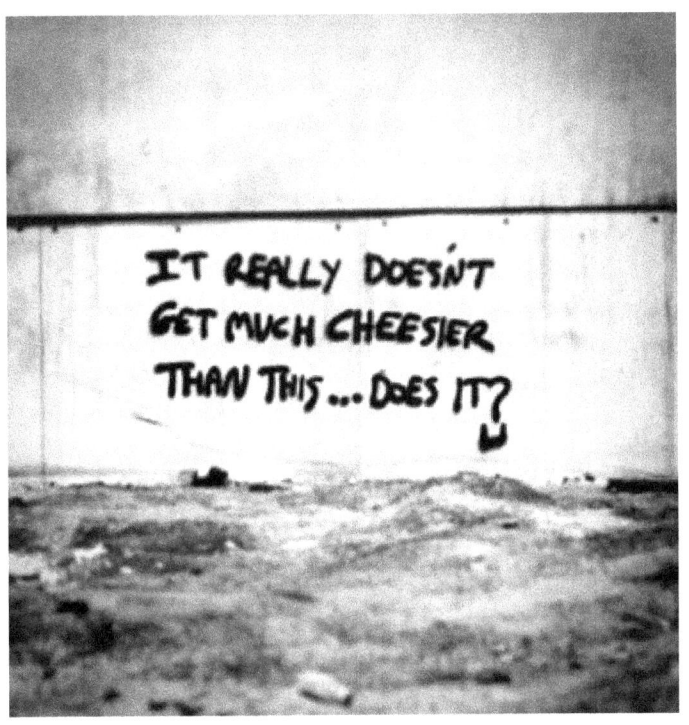

It really doesn't get much cheesier than this... does it?

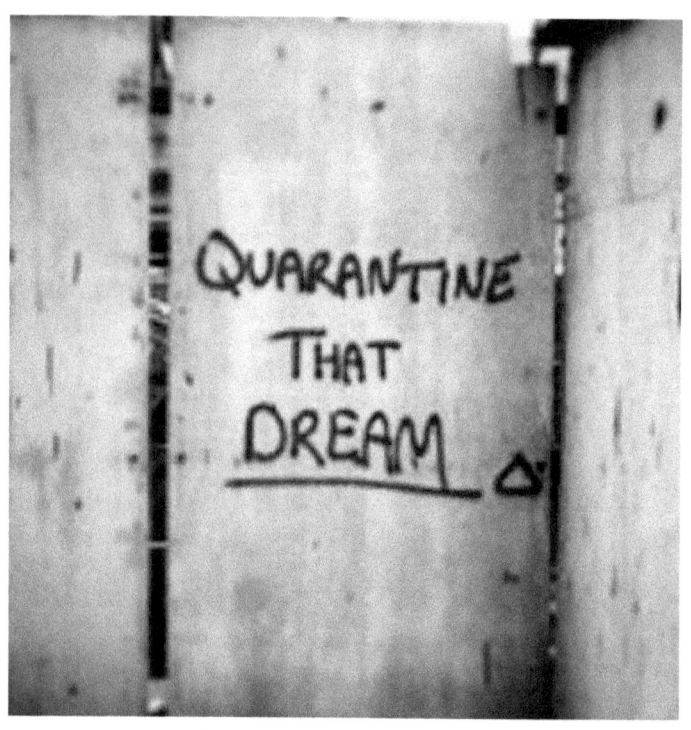

Quarantine that dream.

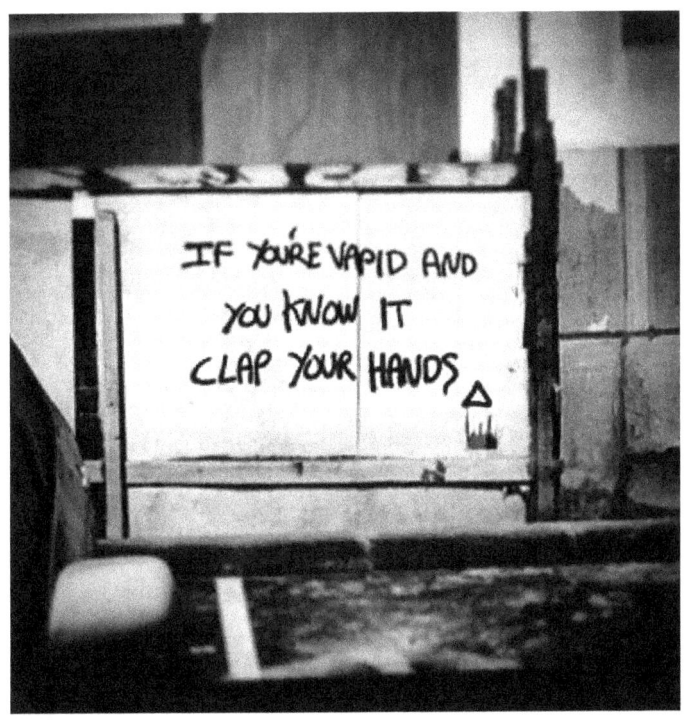

If you're vapid and you know it clap your hands.

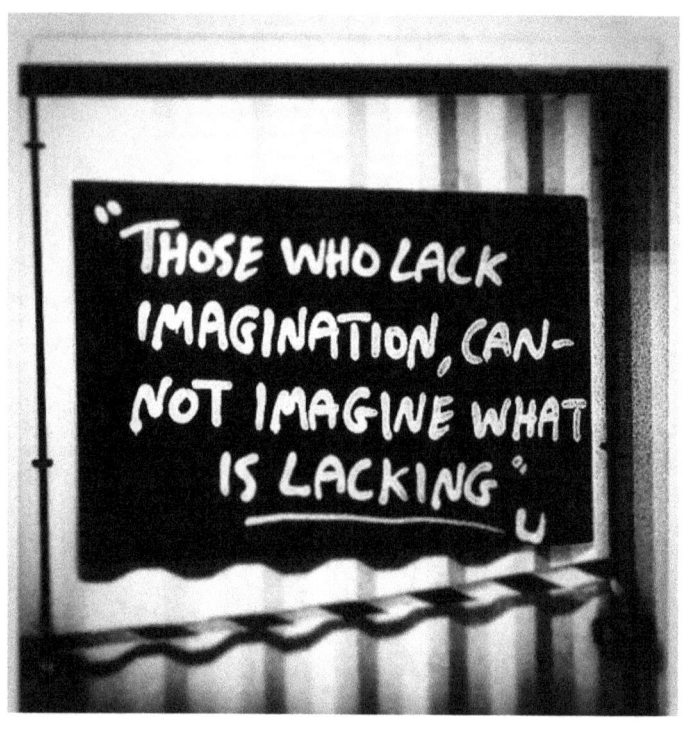

Those who lack imagination cannot imagine what is lacking.

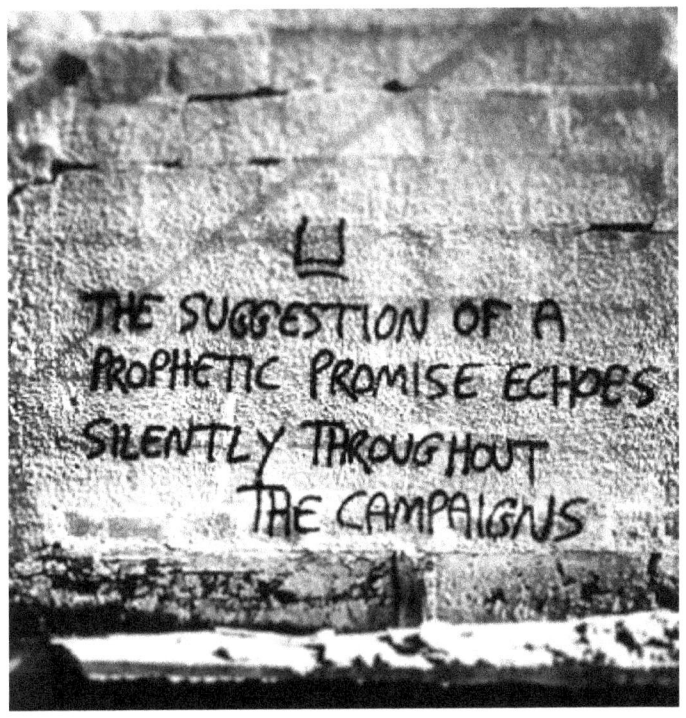

The suggestion of a prophetic promise echoes silently throughout the campaigns.

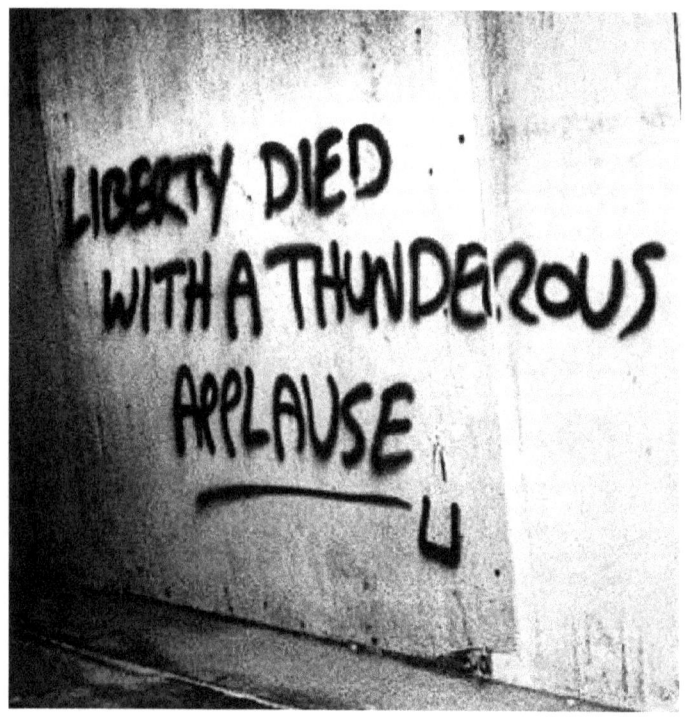

Liberty died with a thunderous applause.

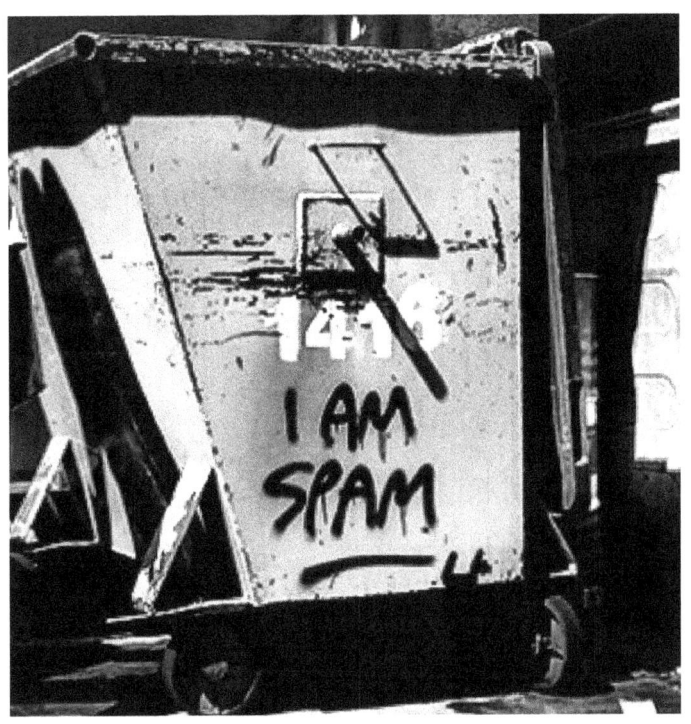

I am spam.

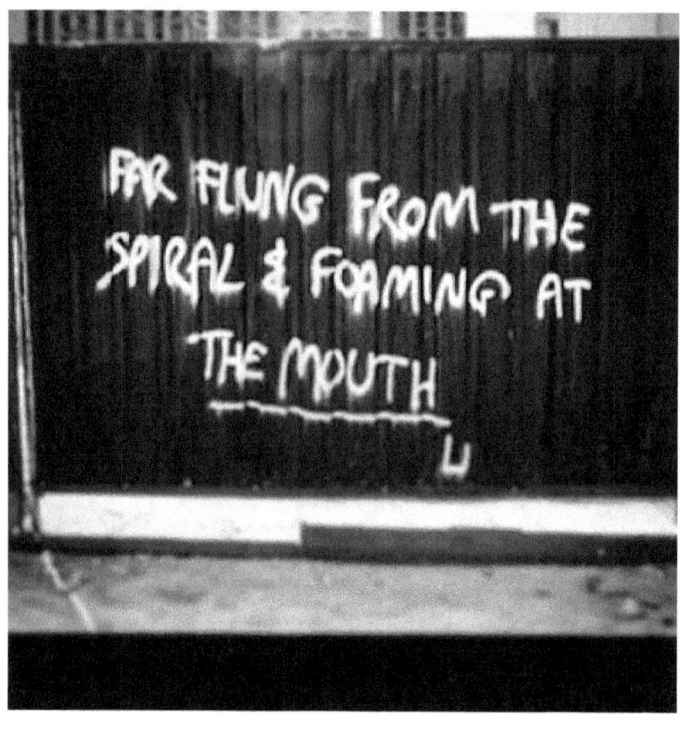

Far flung from the spiral and foaming at the mouth.

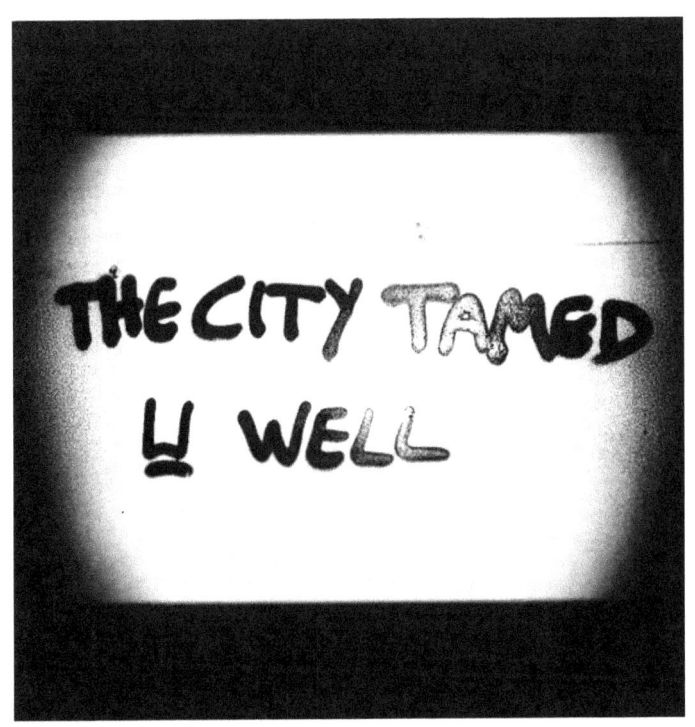

The city tamed you well.

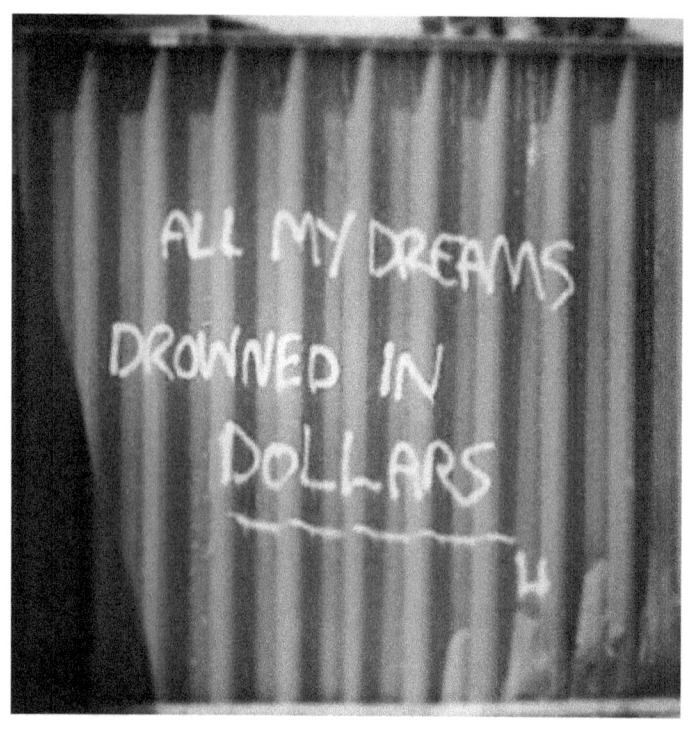

All my dreams drowned in Dollars.

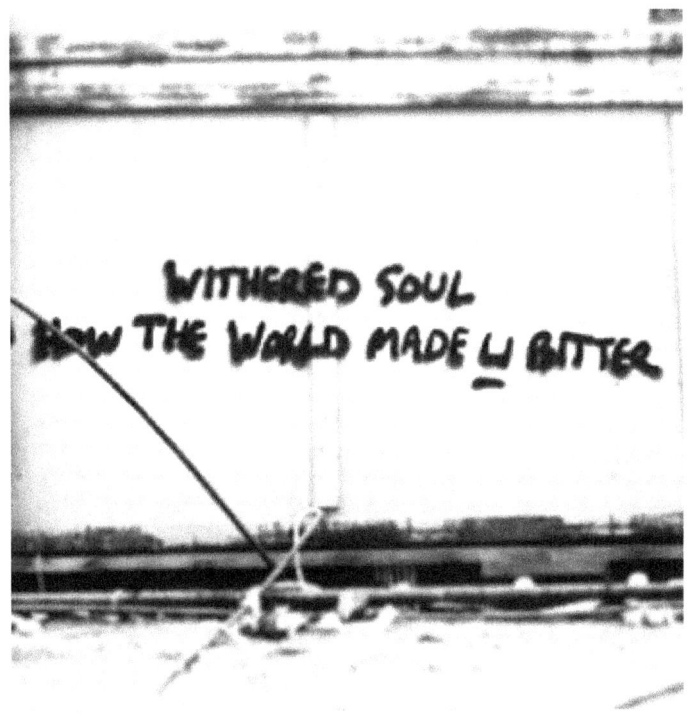

Withered soul, how the world made you bitter.

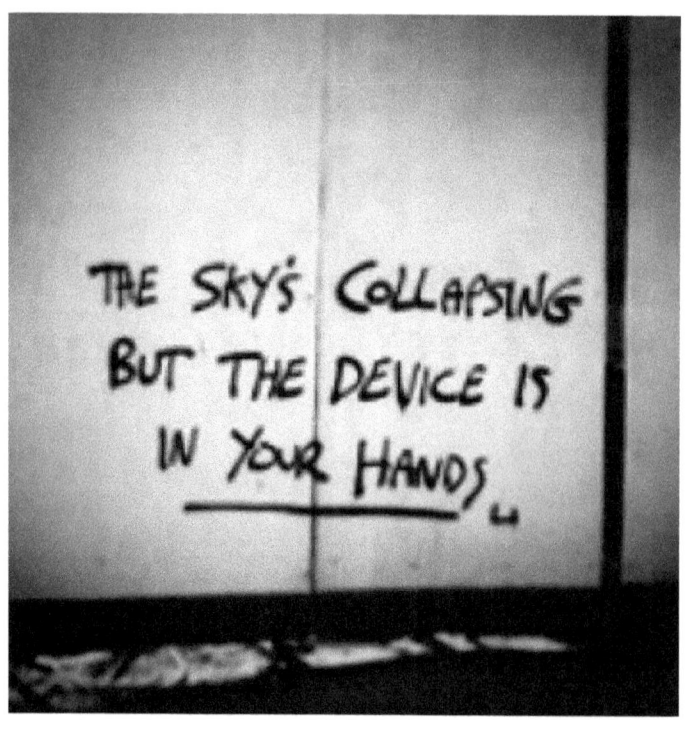

The sky's collapsing but the device is in your hands.

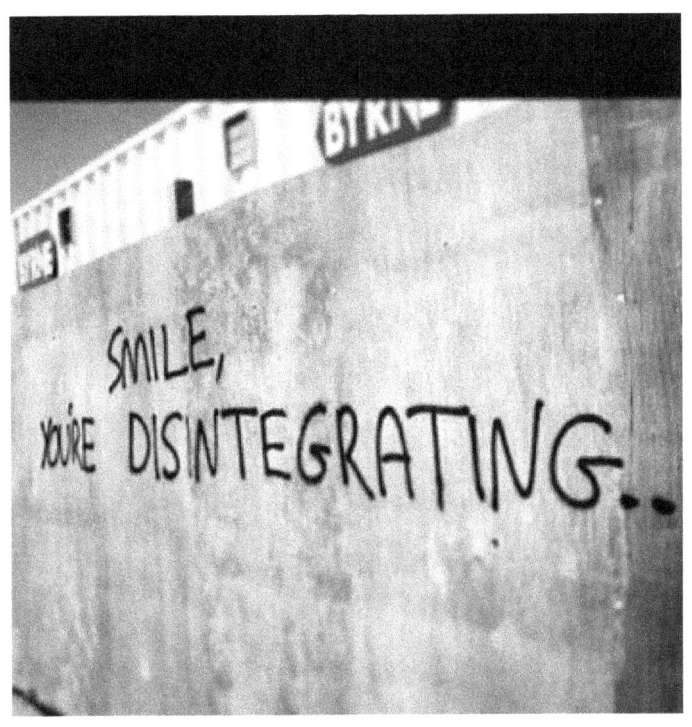

Smile, you're disintegrating.

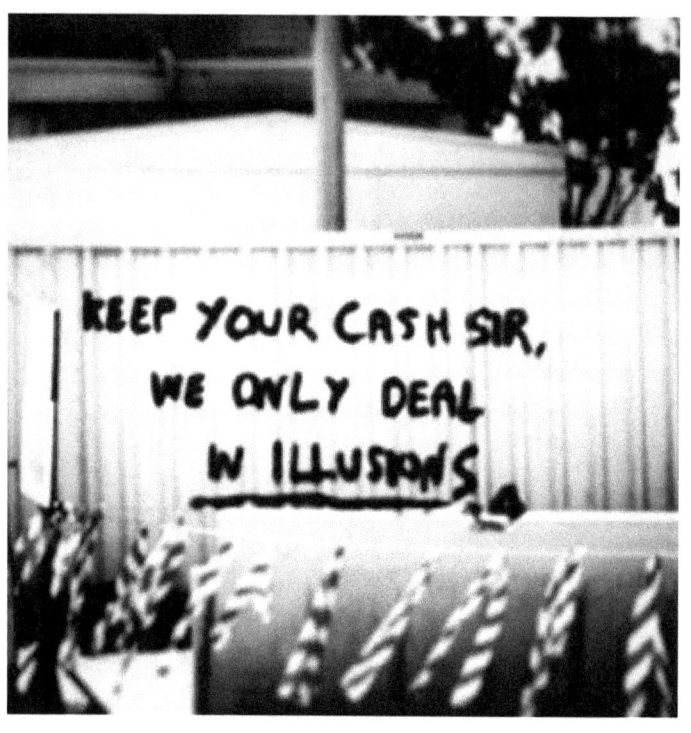

Keep your cash Sir we only deal in illusions.

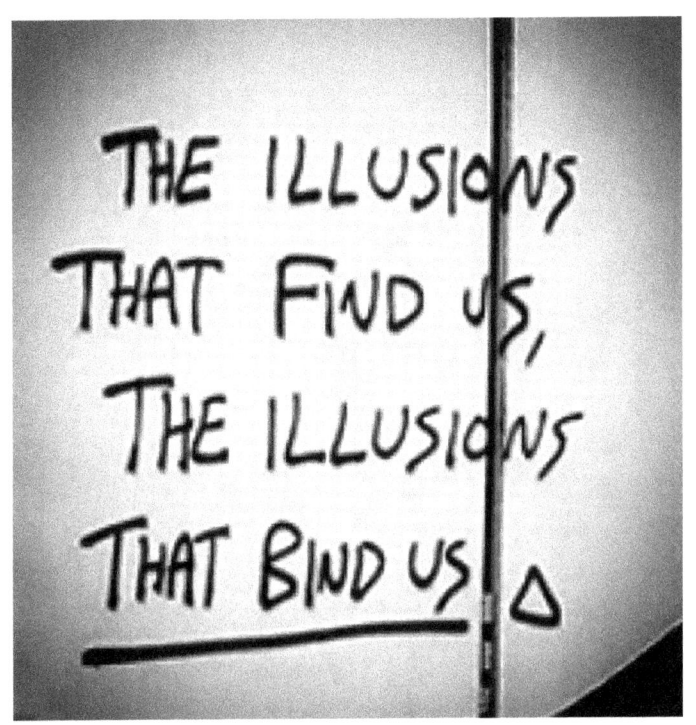

The illusions that find us, the illusions that bind us.

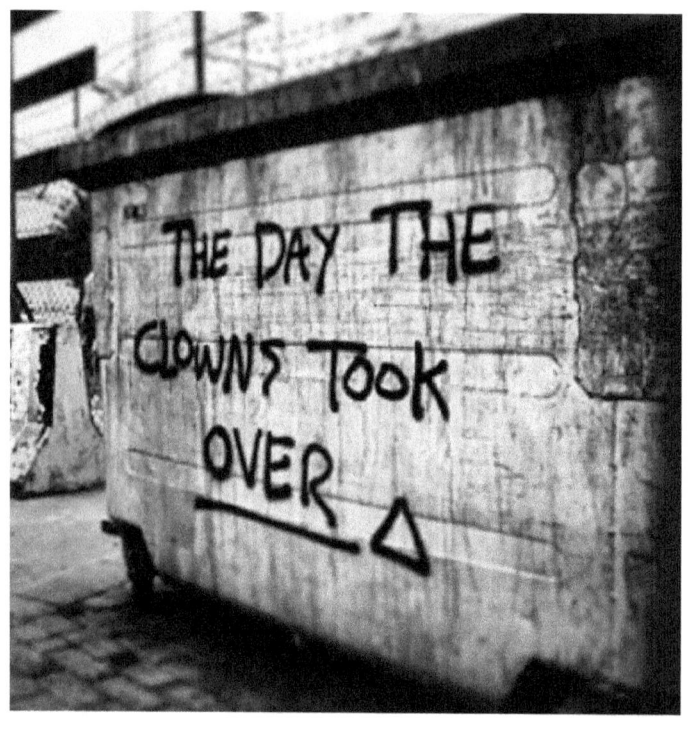

The day the clowns took over.

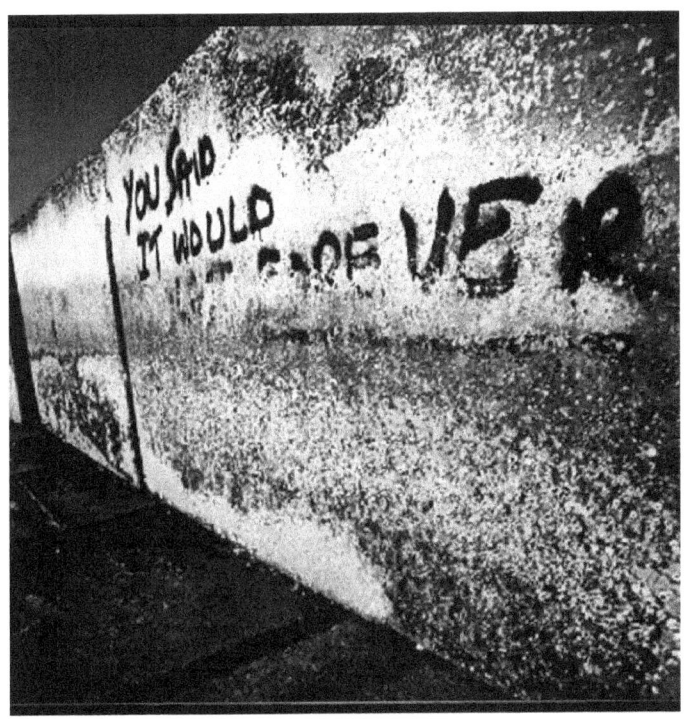

You said it would last forever.

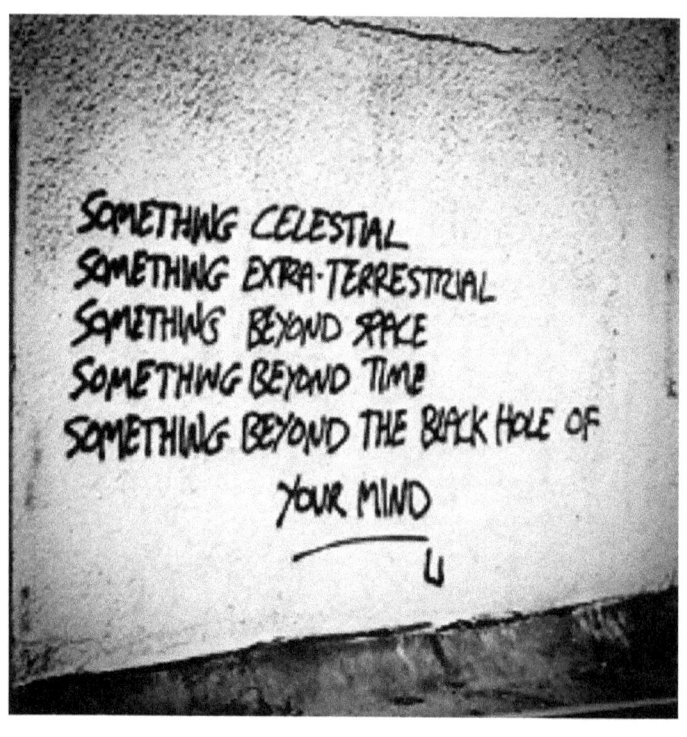

Something celestial
Something extra-terrestrial
Something beyond space
Something beyond time
Something beyond the black hole of your mind.

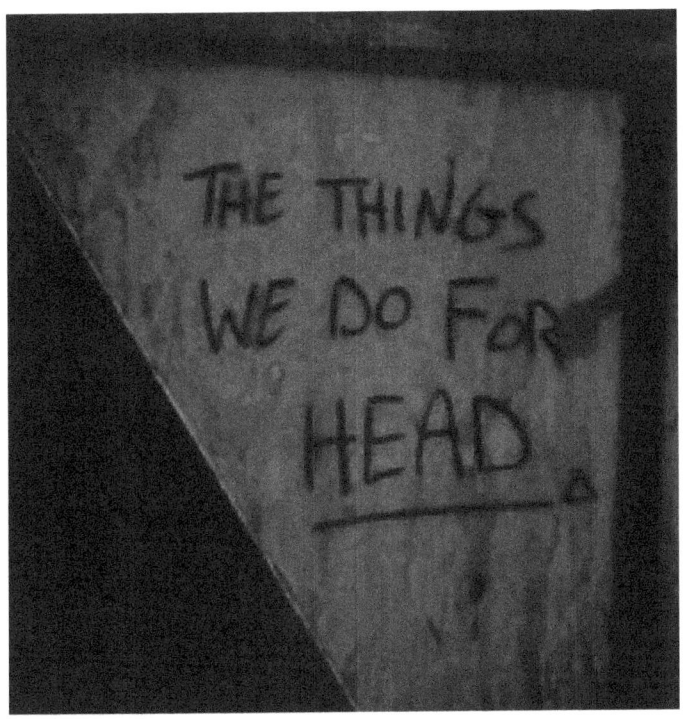

The things we do for head.

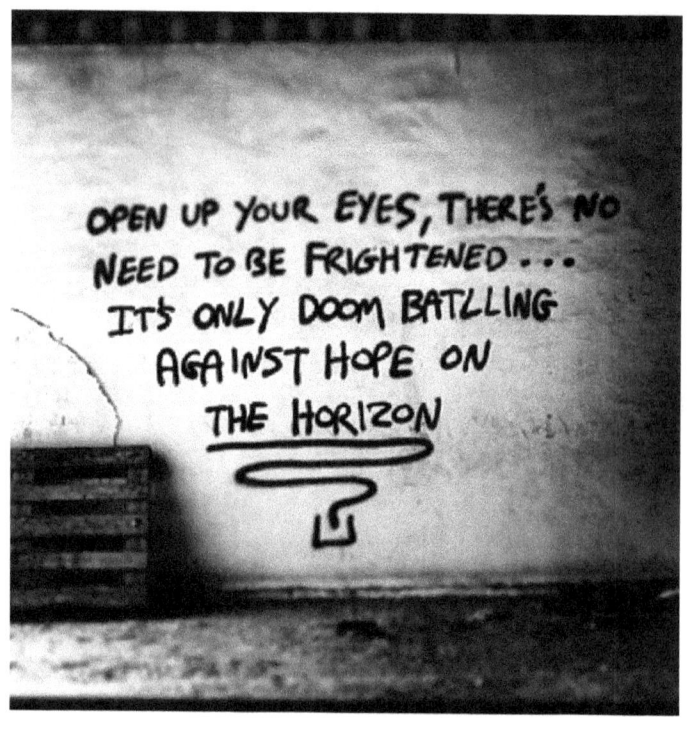

Open your eyes, there's no need to be frightened...
It's only doom battling against hope on the horizon.

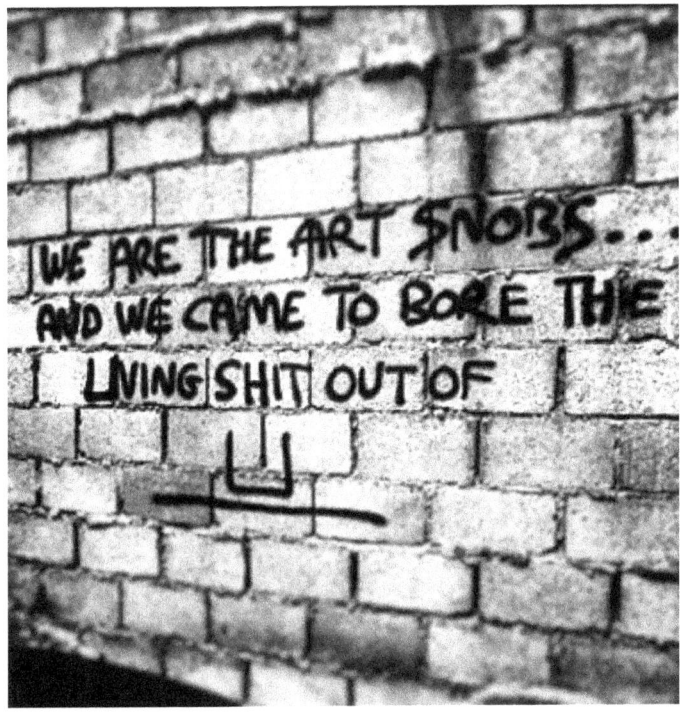

We are the art snobs and we came to bore the living shit out of you.

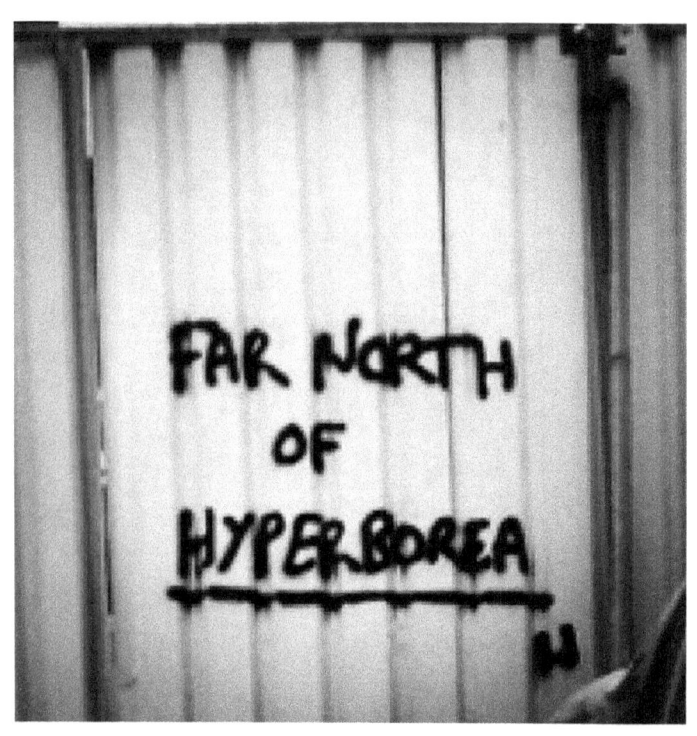

Far North of Hyperborea.

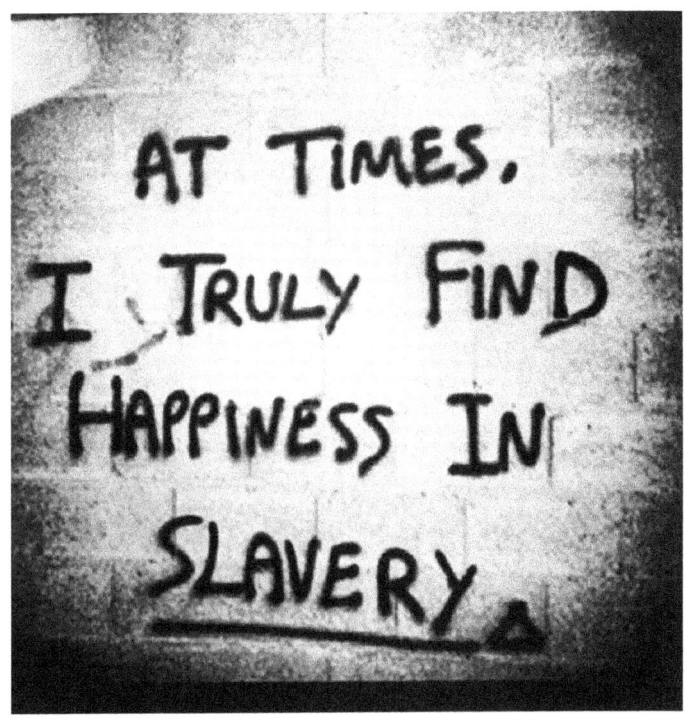

At times, I truly find happiness in slavery.

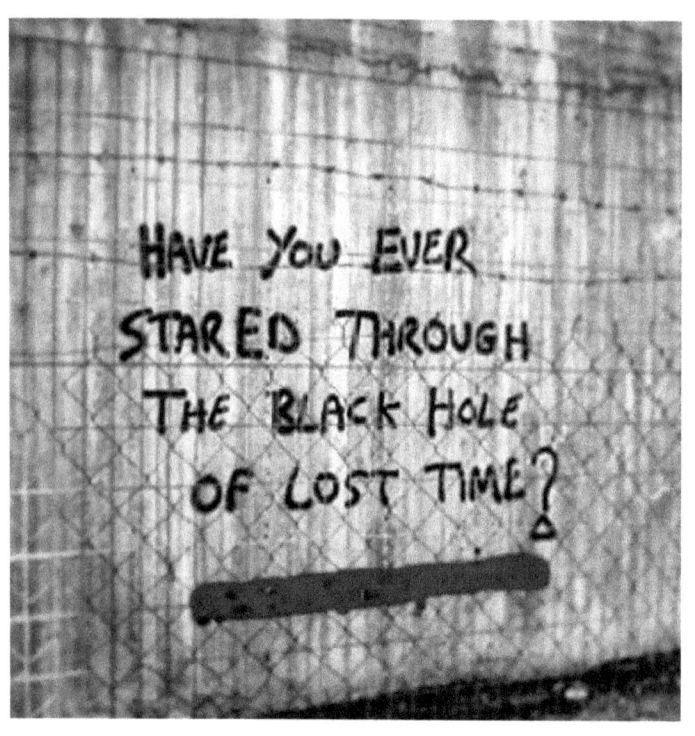

Have you ever stared through the black hole of lost time?

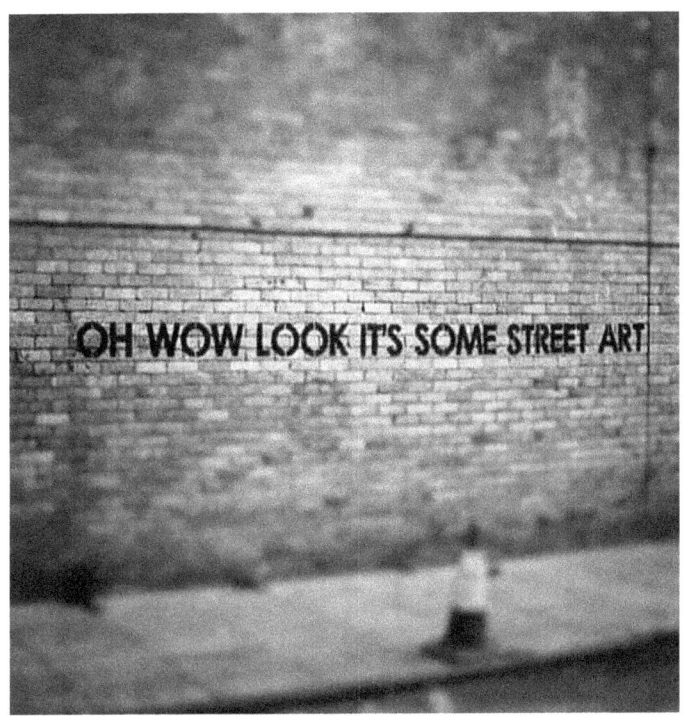

Oh wow look it's some street art.

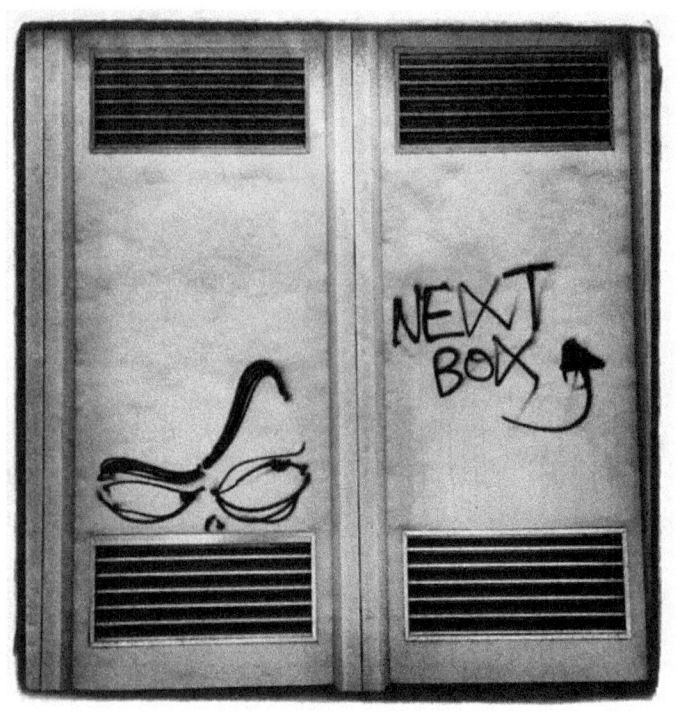

Next box.

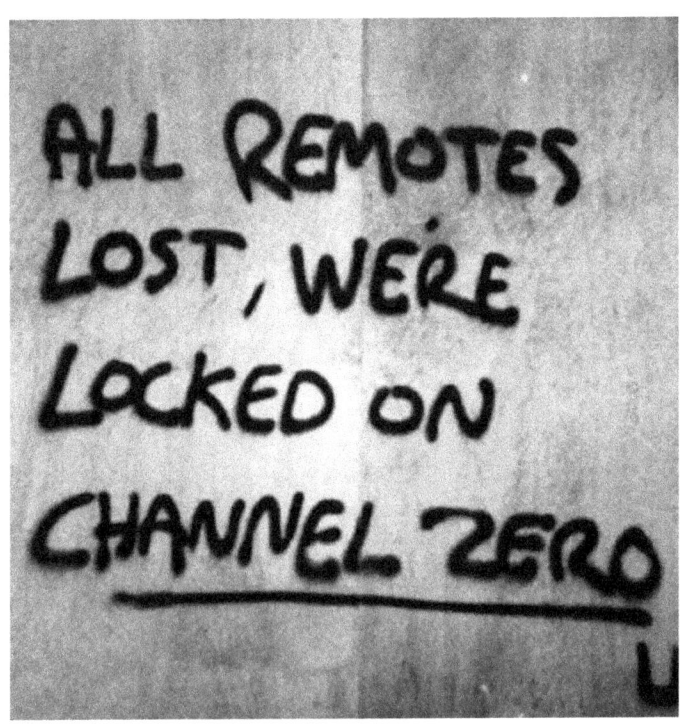

All remotes lost, we're locked on Channel Zero.

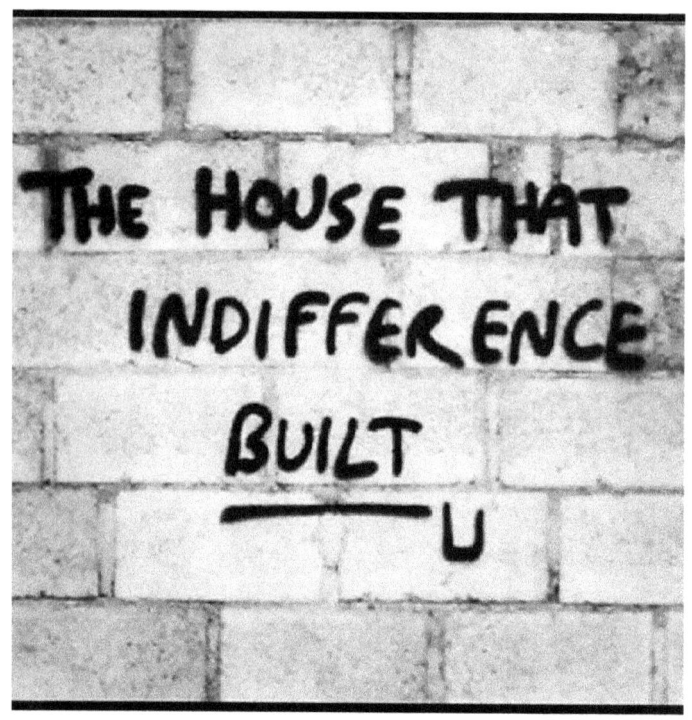

The house that indifference built.

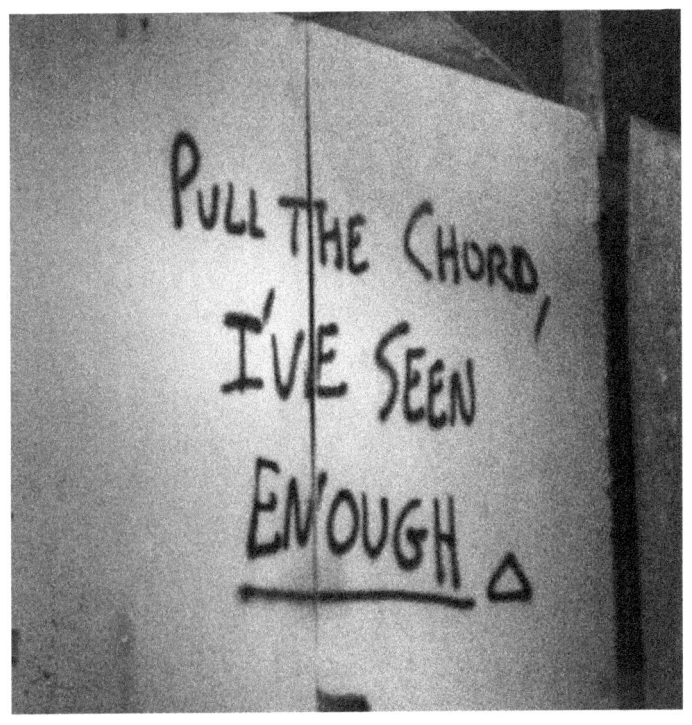

Pull the chord, I've seen enough.

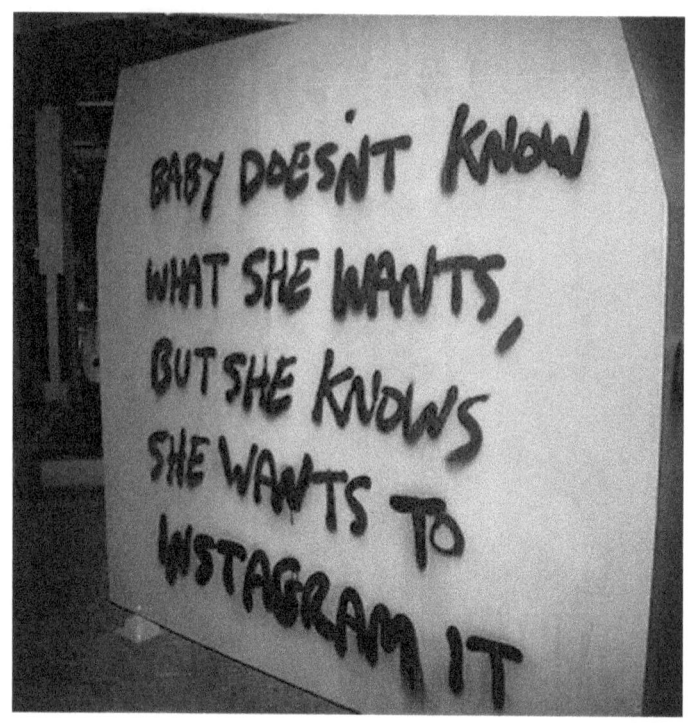

Baby doesn't know what she wants, but she knows she wants to instagram it.

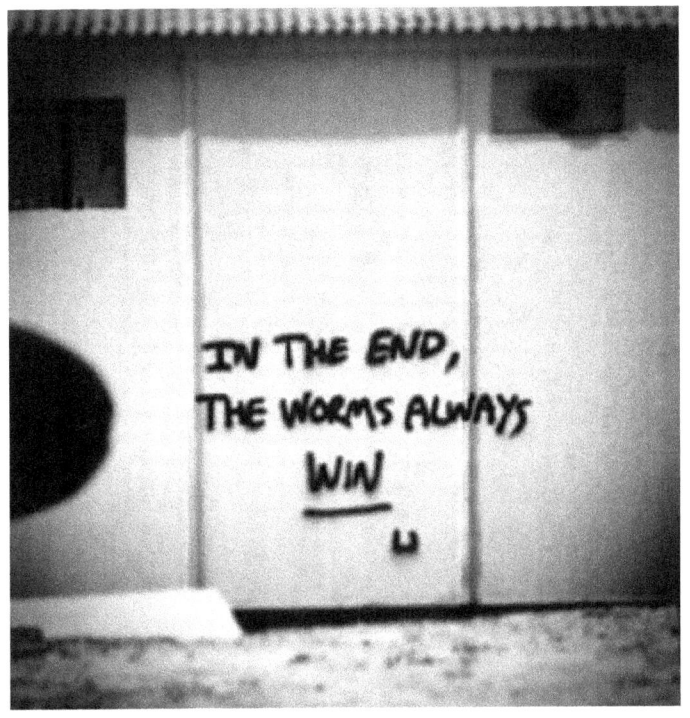

In the end, the worms always win.

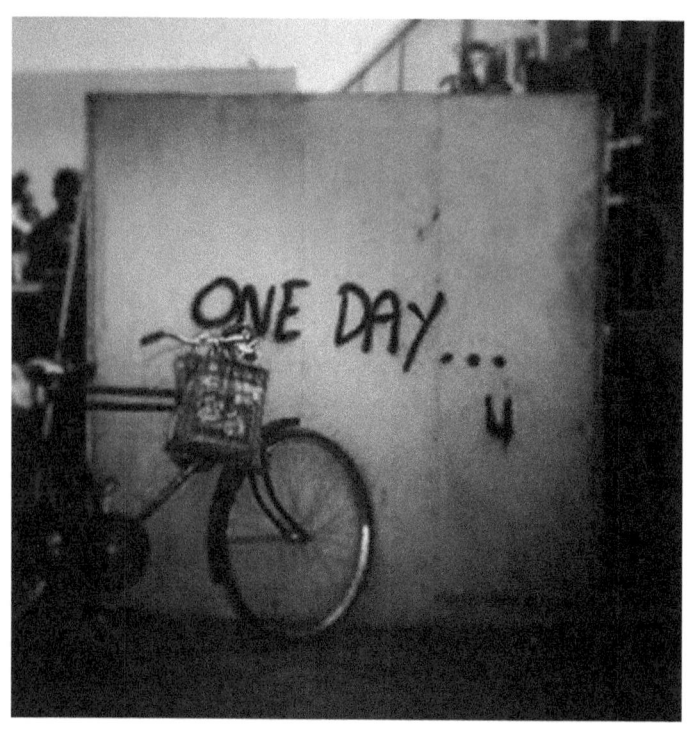

One day...

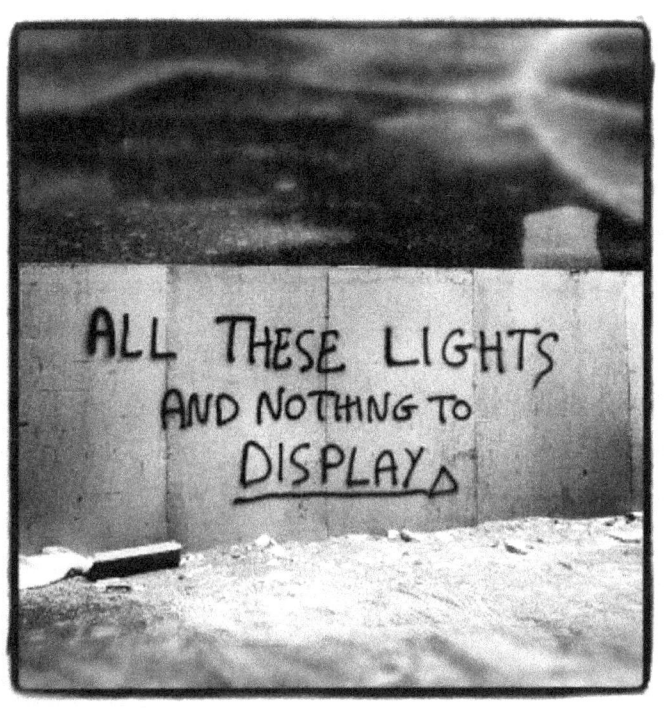

All these lights and nothing to display.

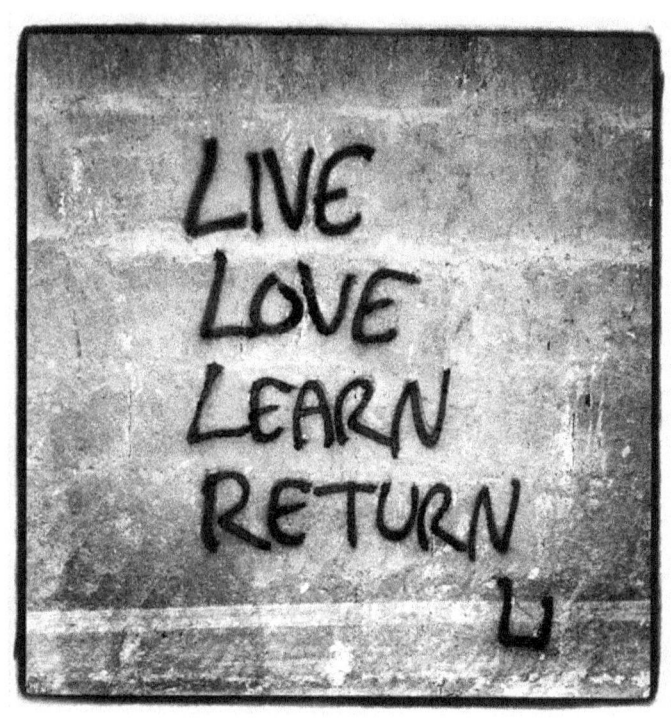

Live
Love
Learn
Return.

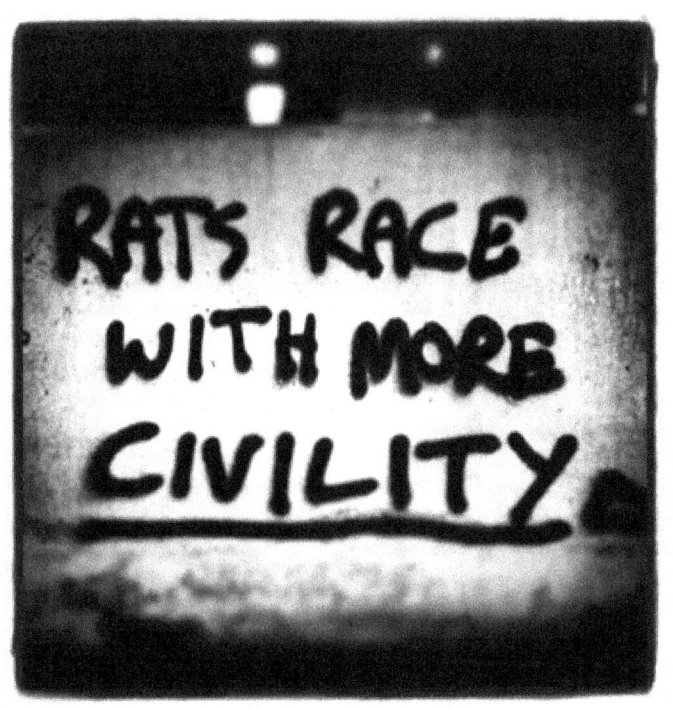

Rats race with more civility.

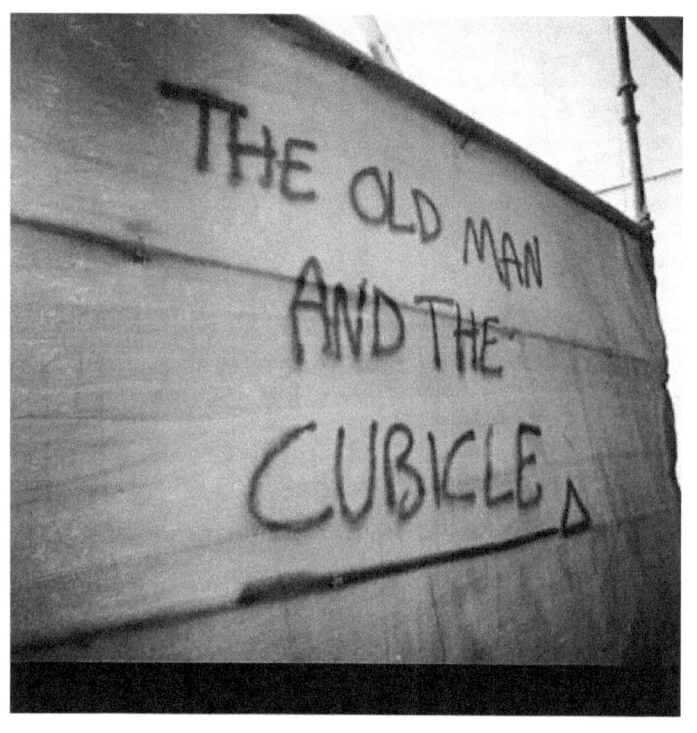

The old man and the cubicle.

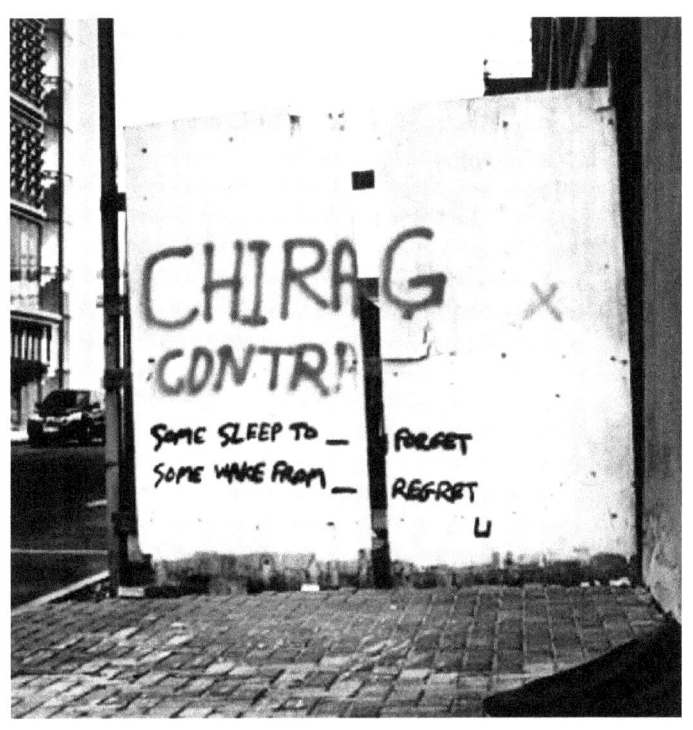

Some sleep to forget.
Some wake from regret.

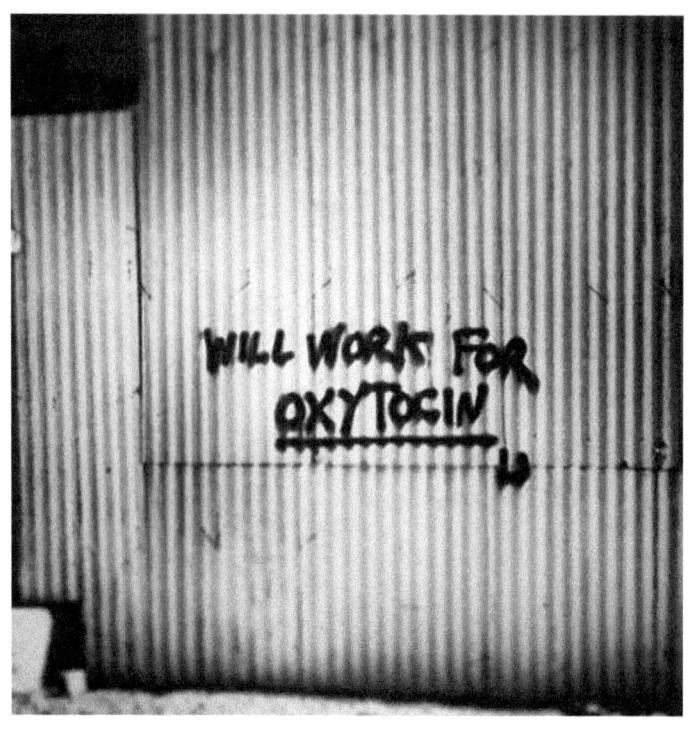

Will work for oxytocin.

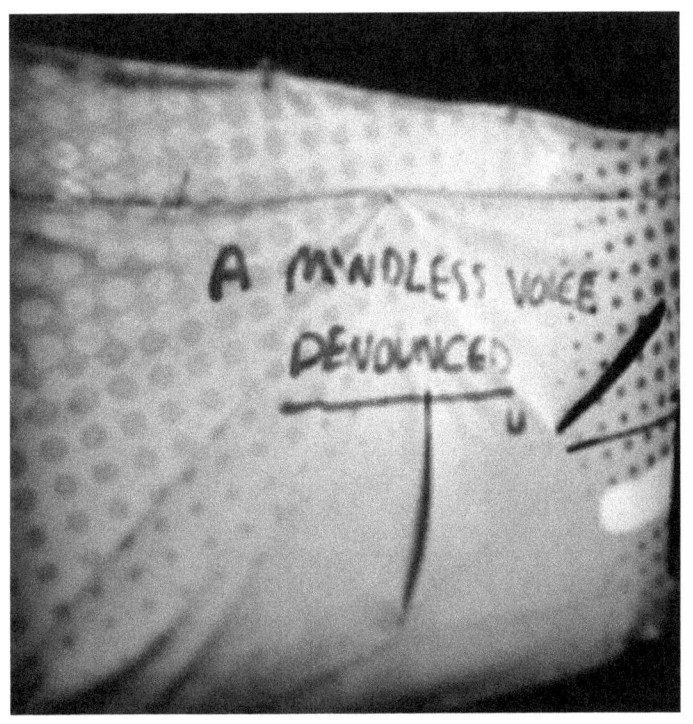

A mindless voice denounced.

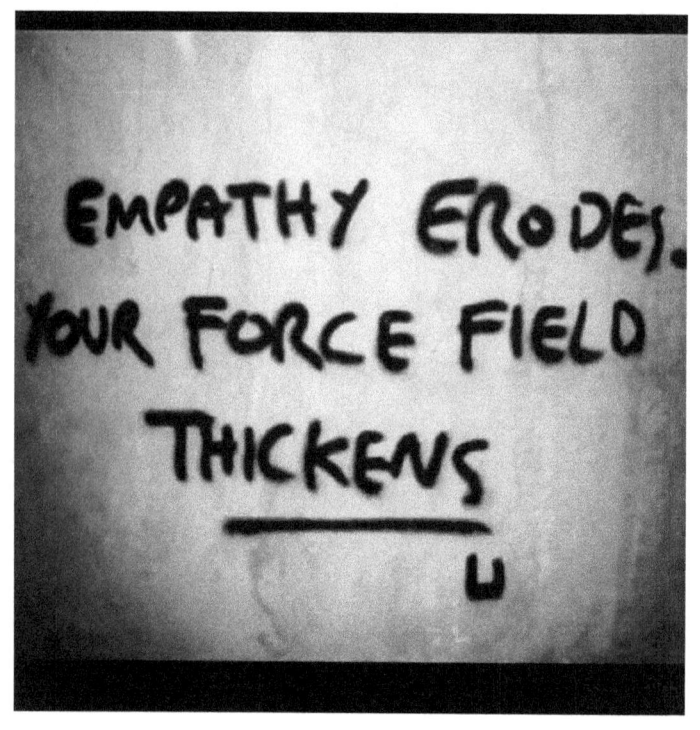

Empathy erodes. Your force field thickens.

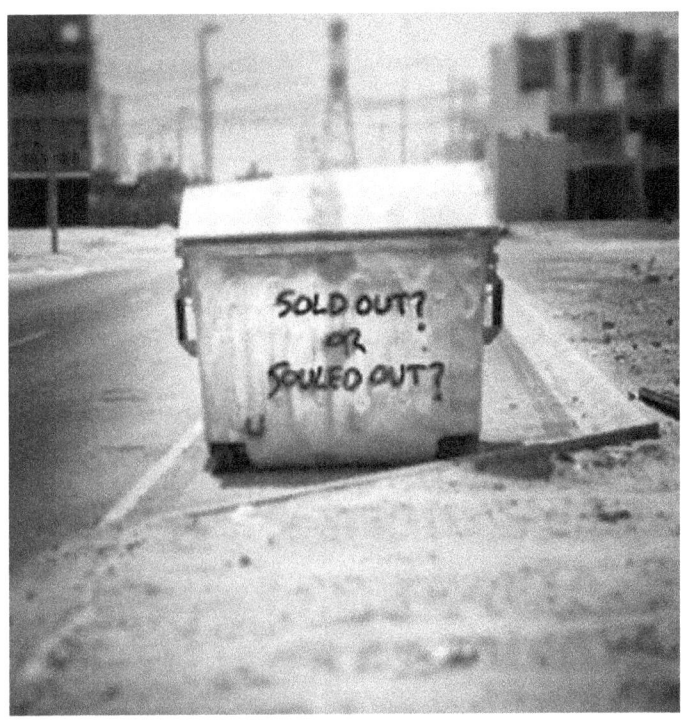

Sold out? Or souled out?

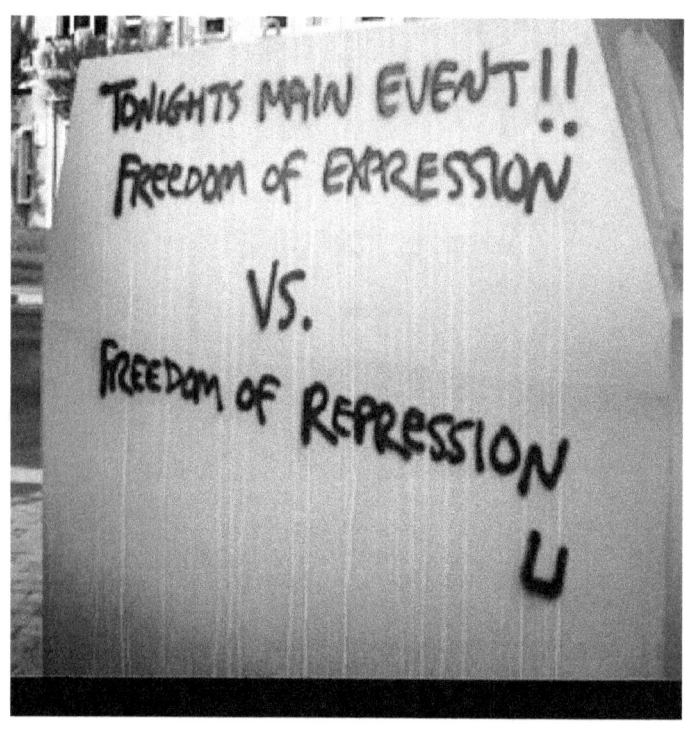

Tonight's main event!
Freedom of expression vs. Freedom of repression.

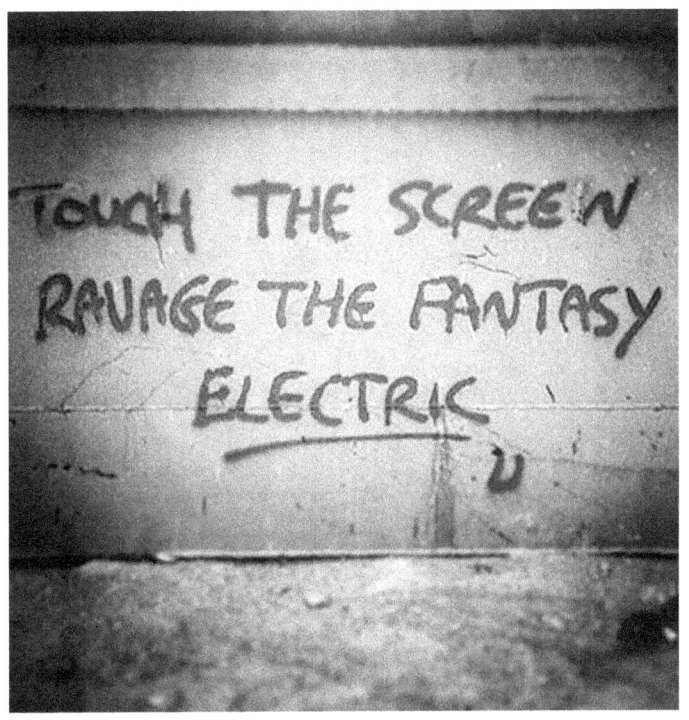

Touch the screen, ravage the fantasy electric.

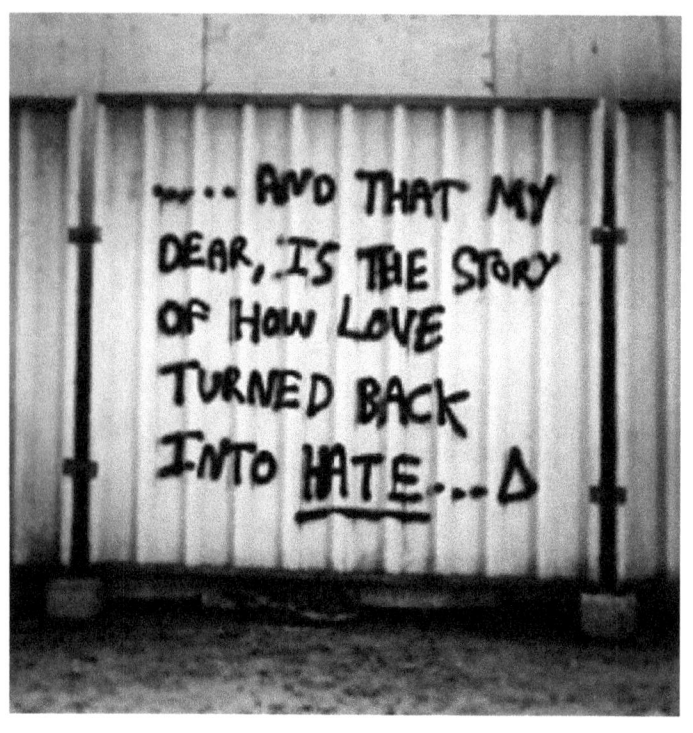

... and that my dear, is the story of how love turned back into hate.

Feedback

If you have any feedback, questions or if you would like for you own work to be included in future editions of this book, please feel free to contact me at this e-mail address:

peter.vg.dubai@gmail.com

Thanks for getting in touch.

About the author

Peter V.G. Kristiansen was born in 1969 in Aalborg, Denmark.
He studied at Aalborg University and the University of Westminster. He holds an MBA in International Business Management.
He has spent eight years as an expat living in, London, Dubai and Khartoum.
He has published ten titles, which are all both available in print and as eBooks.

Other title by the author available on Amazon

1001 Great Inspirational Quotes
A great collection of some of the best inspirational quotes of people who have had a major impact on our history. A reference book anybody drafting a presentation or a speech should keep handy. A good quote can be the heart of a compelling article. Good quotes can help tell a story and enhance the credibility of a press release, an essay, a presentation or a speech.

Words that are crafted well can leave a lasting impact on the world. A great quote or proverb used well in the right context can help convey a message to your audience. Whether you are looking for that perfect quote to round off your

presentation, ideas or inspiration for a speech - or just want to post that really clever tweet or status update, this book contains well over a thousand awesome quotes and proverbs covering a vast range of subjects including: love, hope, leadership, success, teamwork, life, self-development, education, happiness, dreams, opportunity and friendship.

www.ingramcontent.com/pod-product-compliance
Lightning Source LLC
Chambersburg PA
CBHW051717170526
45167CB00002B/696